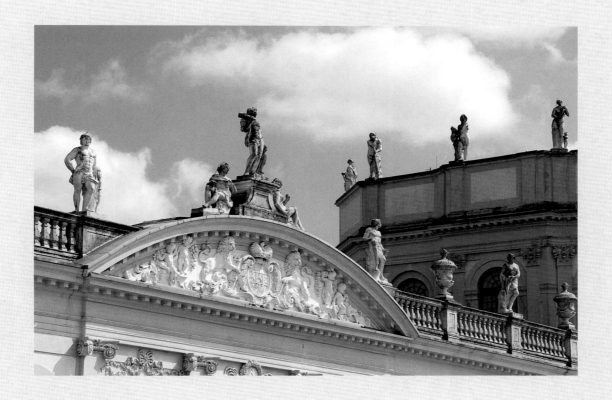

Journey through

HESSE

Photos by
Tina and Horst Herzig

Text by
Ernst-Otto Luthardt

Stürtz

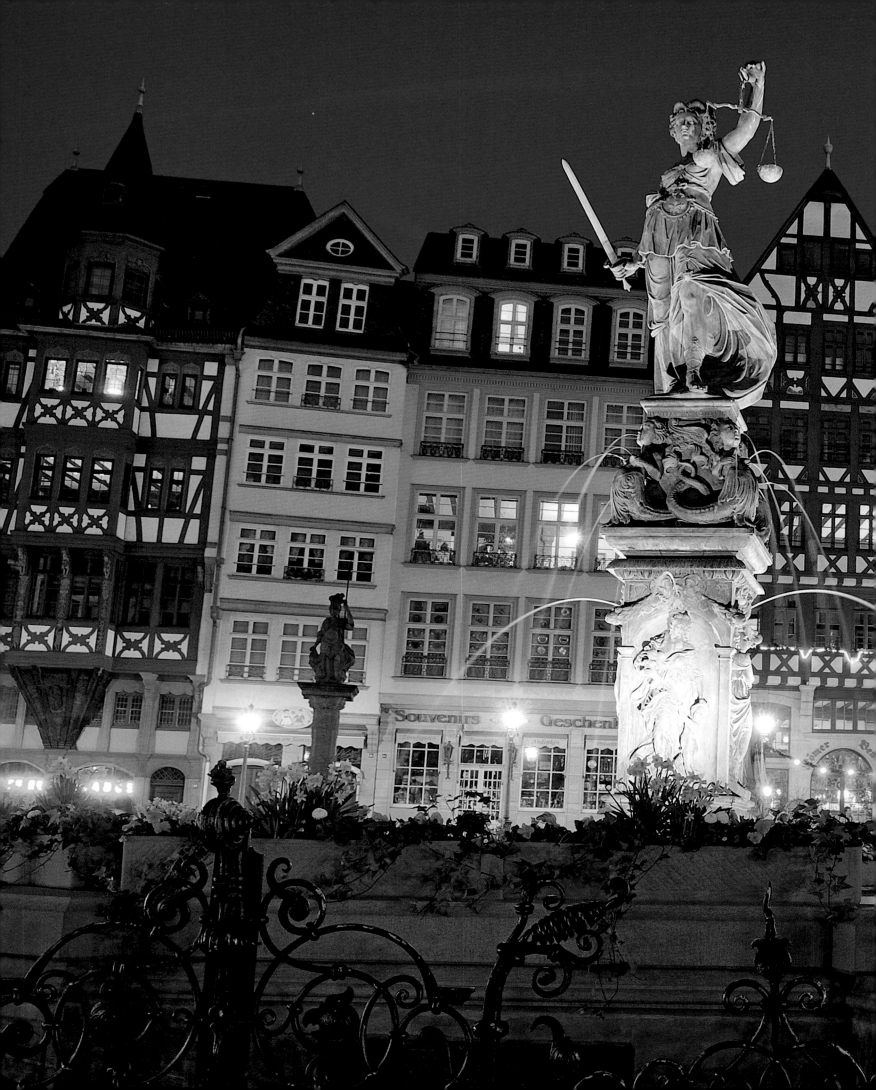

First page:
The palatial orangery in the park of Karlsaue in Kassel, erected at the beginning of the 18th cen-
tury and featuring figures from ancient mythology on its rooftop, is thought to be the work of Paul du Ry
(1640–1714). The elongated building now houses a museum of astronomy and technological history.

Previous page:
Following heavy damage during the Second World War, this façade was only
added to front the new buildings erected behind it on the east side of Frankfurt's Römerberg in the
1980s. The fountain of righteousness in front of it naturally features Justice herself.

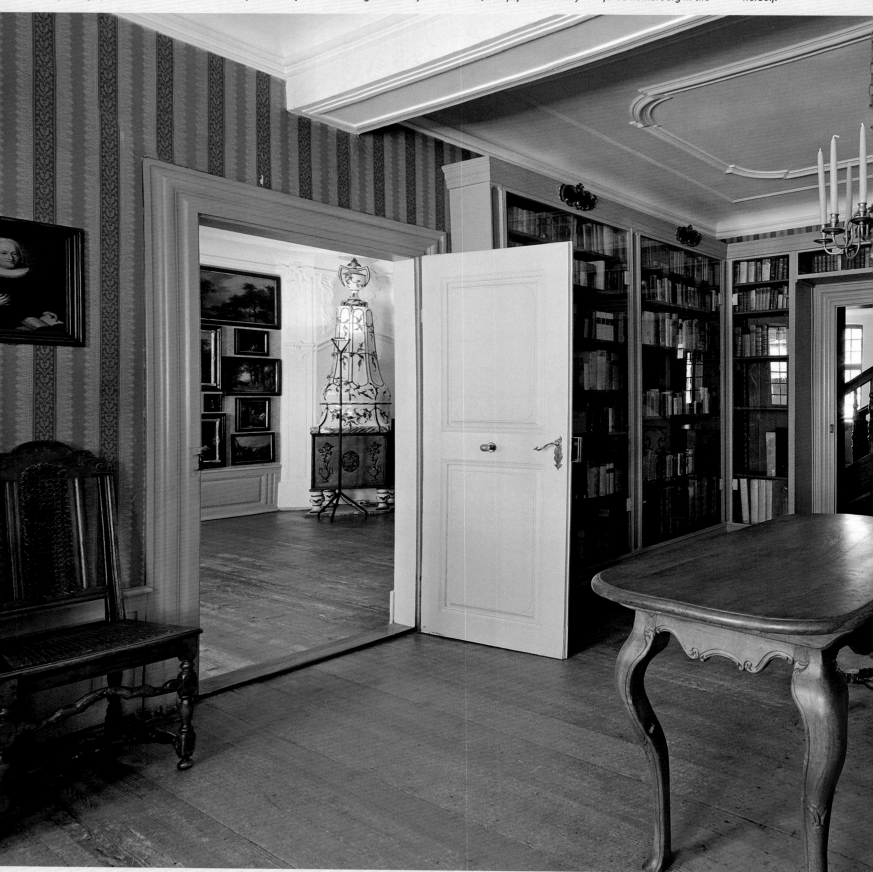

Contents

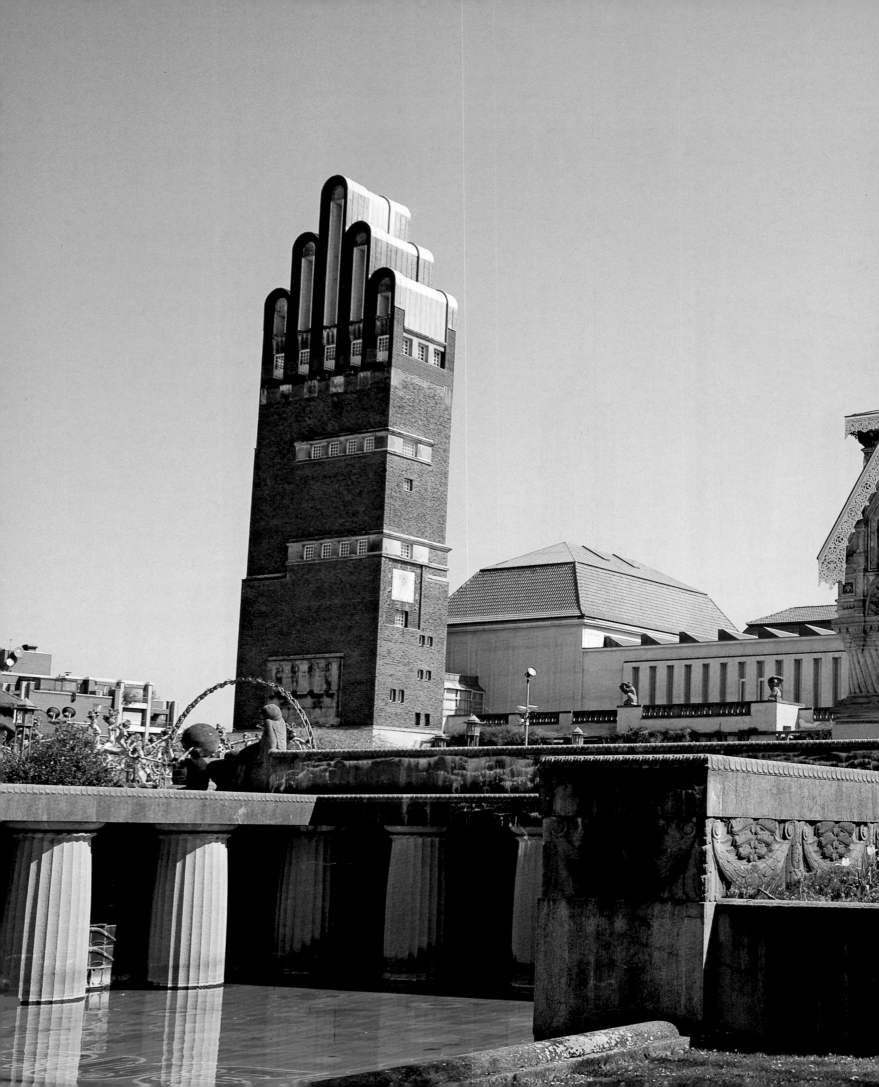

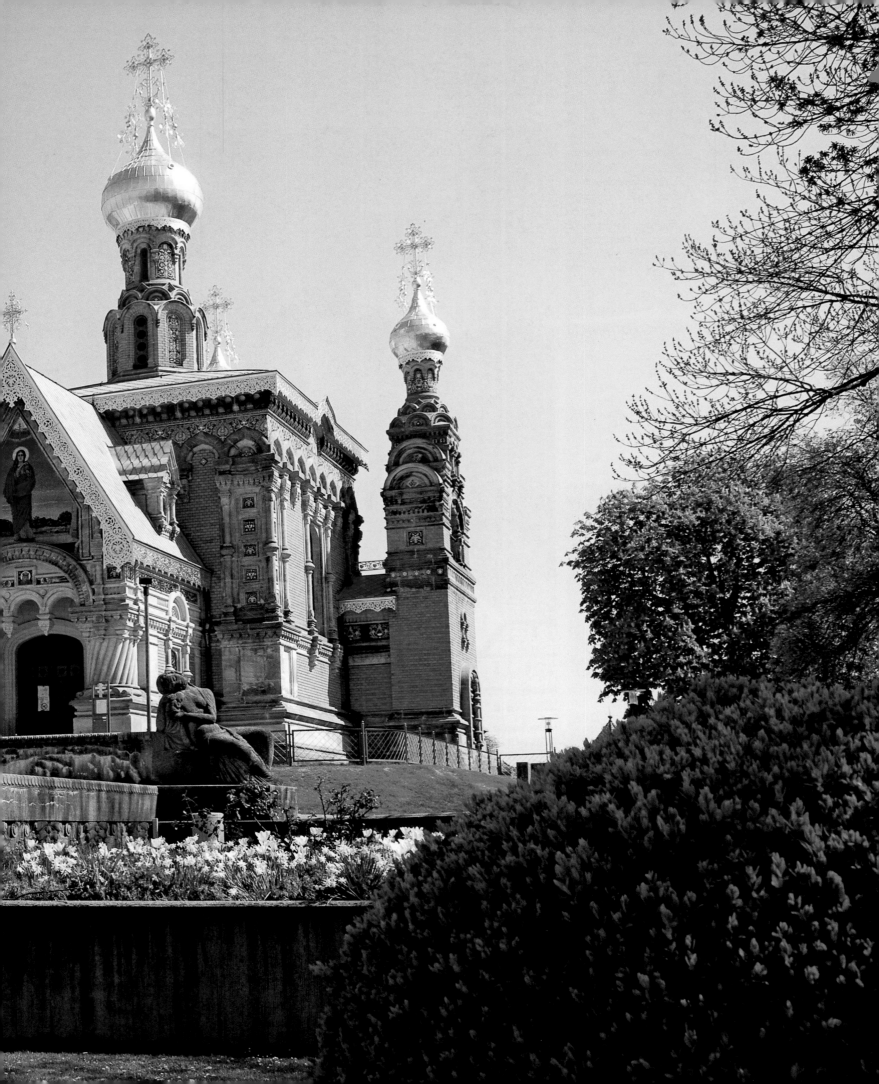

Journey through Hesse

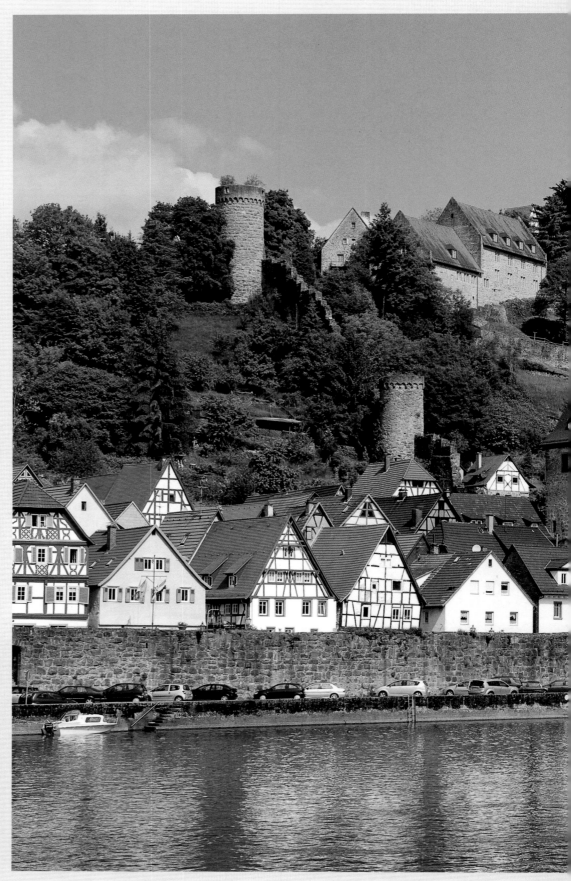

The little town of Hirsch-horn on the River Neckar. The romantic castle, now an exclusive hotel, dates back to c. 1200. Changes and additions were made in the late Gothic period and the great hall is a product of the Renaissance.

*T*he people of Hesse", according to Jacob Grimm, are *"with the exception of the Frisians the only German race who under their asserted ancient name have to this day remained rooted in the same place in conjunction with which they were first mentioned in history."* In the 19ᵗʰ century Grimm could only base his allegation on the fact that the name "Hesse" had remained more or less identical; archaeological findings have since proved that the Chatti described by Tacitus in his *Germania* (98) and the "populus hessiorum" mentioned in a document issued by Pope Gregory III stem from the same family.

Before the ancestors of the Hessians were able to take control of the land of the Kinzig and Lahn, Schwalm and Ohm, Diemel, Fulda and Eder rivers, they first had to drive out the Celts. This probably wasn't too difficult, for they were known to be fierce and fearless in battle. Tacitus claimed they were particularly strong, "of a stocky build and with a terrifying look". Whether true or not, they managed to ward off all attempts by the Romans to 'integrate' them and earned themselves so much respect that their would-be conquerors set about building a defensive wall or Limes around the Chatti's territory as quickly as possible.

The political – and possibly also religious – centre of the first Hessian tribe was called Mattium. Recent excavations allow us to assume that this was probably close to the villages of Metze and Maden in the Schwalm-Eder district affiliated with Niedenstein and Gudensberg.

The search for their 'capital city' is not the only puzzle the Chatti have left their successors to solve. We still don't know for sure if the legendary salt battle in the year 58 they lost to the Hermunduri was fought on the River Werra or perhaps on the River Saale, for example. We also have no idea what they did in the five hundred years between their last mention in 213 and the first of the Hessians in 738 and in how far they were able to retain their identity under Frankish rule.

The legacy of St Boniface

Even if He didn't appear in public, as is His wont, it goes without saying that the monastery in Fulda was built in the name of God. The man selected for this honourable task was none other than His famous Irish disciple St Boniface, entrusted with the founding of a new Benedictine order in deepest heathen country and converting the local populace to Christianity. Boniface, however, didn't actually do the job himself but commissioned his pupil Sturm, who in 744 duly laid the foundations for the project.

Made an imperial abbey in the very same century, the monastery not only grew to become the largest, richest and mightiest ecclesiastical centre of power after the Vatican but was also the intellectual nucleus of the empire. The learned abbot Rabanus Maurus (c. 780–856) turned the monastic school into an scholarly institution of the highest repute, with the list of pupils reading like a *Who's Who* of the day and age. The abbey library, with its 2,000 manuscripts, also set standards that were hard to match.

The monastery and its initiator Boniface were only reunited after the saint's martyrdom in 754. Despite the great desire expressed by his former episcopal see his mortal remains were not taken to Mainz but to Fulda. The veneration he met with there was confined to the region for many centuries. It was the 19th century that made him the Apostle of the Germans. Boniface was much more than this, however, being one of the chief architects of Christian Europe. Of the original places of worship built in and around Fulda all that has survived from the 9th century are the crypt of the Michaelskapelle and the Liobakirche (Petersberg). The latter boasts the remains of frescos which are among the oldest in Germany. Hesse also has other wall paintings of note, namely the crypt of St Andreas in Neuenburg from the 11th century which, as Father Winfried Abel explains, is the only completely frescoed church interior from the Ottonian period besides St George's on Reichenau Island in Lake Constance.

Devilish deeds in the Odenwald

Besides Fulda Hesse has two other momentous sites from the Carolingian period in Hersfeld and Lorsch. These three enormous monastic churches, of which little has survived, bear witness to the great significance of the region within the Frankish Empire. After this was divided in 843, the German Carolingians made Lorsch their place of burial. The imperial abbey, made a UNESCO World Heritage Site and whose magnificent gatehouse has been bequeathed to us fully intact, is also mentioned in the

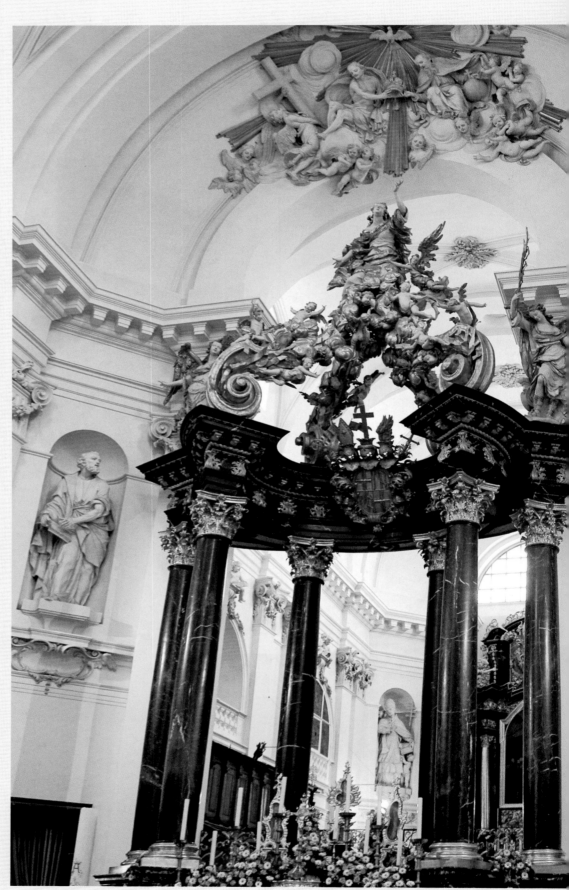

The cathedral in Fulda is the work of Johann Dientzen-hofer (1663–1726) who was personally recommended by the pope. The man who commissioned the construction was Prince-Abbot Adalbert von Schleifras. Before work could begin the cathedral's famous Carolingian predecessor, the Ratgar Basilica, had to fall prey to the pickaxe.

Nibelungenlied or Song of the Nibelungs, the most famous heroic epic of the Middle High German period. Lorsch appears in what is known as Manuscript C, one of several written versions of this monumental piece of literature. It was first written down in c. 1200. The poem tells of the rise and fall of the Burgundian Empire at the beginning of the 5th century. Some of the protagonists are historical figures, such as the kings Gunther (Gundahar) and Etzel (Attila), others are the stuff of legend. The latter include dragon-slayer Siegfried, a kind of early Superman whose extraordinary powers were to be the bane of his life, such as a cloak that made him not only invisible but also incredibly strong.

When Gunther's wife Brünhild learns that she is defeated in the duel upon which her promise of marriage depends not by her present husband but by Siegfried, she becomes his archenemy. Yet the hero has bathed in dragon's blood, rendering him invincible – with the exception of a small patch of skin between his shoulders that was covered by a linden leaf.

In order to save his lady's honour, Brünhild's liegeman Hagen of Tronje hatches out a devious plan. He invites Siegfried to go hunting with him and as his guest bends down to drink from a stream, Hagen strikes his deadly blow to the hero's only vulnerable spot.

This devilish deed is thought to have taken place in the forest of the Odenwald; the aforementioned Manuscript C at least claims so, giving Lorsch Monastery as the place where the hero was laid to rest.

The Hessian towns of Grasellenbach, Heppenheim, Hiltersklingen and Lautertal – and Baden-Württemberg's Odenheim – all lay claim to being the site of the Mordquelle or murderous spring. Great care is thus advised in several respects when embarking on investigative tours of the Nibelungen-Siegfried-Straße tourist route ...

Hesse's rebellious and compassionate saint

Women of her calibre were and still are few and far between; she could be a modern-day role model. Elisabeth, princess of Hungary, was sent to Wartburg Castle aged just four to

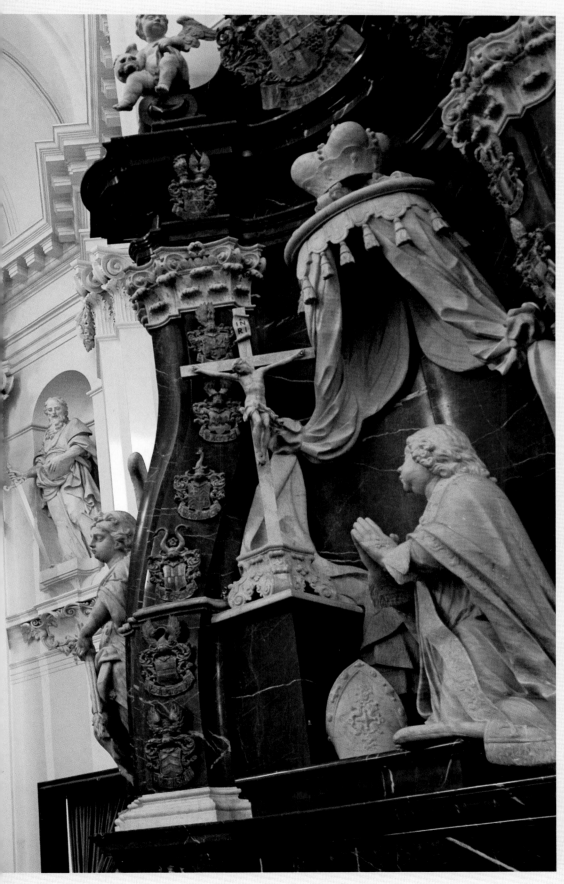

be betrothed to a Ludowingian – and spent the rest of her short life flying in the face of convention. She treated her subjects first and foremost as people; class and status were of little value to her. She saw where help was needed – and gave it willingly. She not only opened her heart to the people but also the landgrave's stores of grain and chests of gold. She was even not above personally tending to the sick and the leprous.

The royal dropout was not trying to pull a huge publicity stunt; she was merely living her beliefs. Convinced that focussing on heavenly paradise did not absolve a person from his or her earthly duties, compassion and fairness were of great importance to her. She only considered worldly goods to be of any significance in as far as she could give them to those who were in greater need than herself.

It thus comes as no great surprise to learn that with her generosity Elisabeth made few friends at the landgrave's court. Her only loyal companions were her husband Ludwig, who loved her more than anyone and anything else in the world, and her confessor Konrad von Marburg. On the death of Ludwig she thus had little choice but to leave the Wartburg and seek a new home – which she found in Marburg. Yet the woman who worked as a nurse in the hospital she herself had founded with no regard for her own strength and wellbeing was no longer the widow of a landgrave but merely a good Samaritan.

Elisabeth died at the age of 24. She was made a saint in 1231. A few years later, after her daughter Sophie of Brabant had won the landgravial crown for her son Heinrich in the bloody War of the Thuringian Succession (1247–1263), Elisabeth was named the "first lady of the land of Hesse".

Palatial residences and the 'romantic' castle

Slowly squeezed by the competition from Saxony and Bavaria it was a matter of political survival for the Staufer dynasty (1138–1254) to strengthen their seat of power. They thus set about fortifying their ever growing centre of trade Frankfurt and also its environs, catapulting Hesse back into the limelight of imperial politics.

With the Staufer's defensive structures and representational edifices, such as the Saalhof in Frankfurt, the imperial palace in Gelnhausen and the administrative castles of Büdingen and Münzenberg, Hesse began to build up its own network of strongholds and citadels. Thanks to the endeavours of various knights and sacred and secular rulers the number continued to

increase and the region became one of the best fortified in Germany. Model castles were constructed, among them Friedberg in the Wetterau, Runkel an the River Lahn and Ehrenfels on the Rhine, now a ruin. The more splendid venues include Bad Arolsen (the "Versailles of Hesse"), Kassel (Wilhelmshöhe, Wilhelmsthal and the orangery), Marburg, Weilburg, Fulda (the Residenz and Adolphseck) and Erbach.

The Steckelburg in the valley of the Kinzig fared less well; all that remains of it are the curtain wall, bits of a residential building and one tower. The castle's lord, Ulrich von Hutten (1488–1523), earned a name for himself as a great poet and intrepid visionary. In 1522 he staged an armed rebellion of imperial knights together with the outlawed Franz von Sickingen, aiming to gain independence from the Roman clergy and reunite the divided empire to restore it to greatness and glory. What actually happened was disastrous: Franz von Sickingen was killed immediately and Ulrich von Hutten slowly. On the run, the terminally ill von Hutten, made poet laureate by the emperor in 1517, suddenly found himself with no friends ...

If you want to find out what a 'romantic' castle was really like, read von Hutten's letter to his friend Pirkheimer, a Humanist in Nuremberg: *"Regardless of whether a castle is built on a hill or on a plain, it is definitely not designed for comfort but for defence, surrounded by ditches and walls, its interior oppressively cramped, packed in between the animal stalls and stables ... Everywhere stinks of gunpowder and the smell of the dogs and their waste is no more pleasant, I think. Riders come and go, among them robbers, thieves and highwaymen ... And what a noise! Sheep baaing, cattle lowing, dogs barking ... And each day you have to watch out for the next, always moving, always restless."*

Of spas and spa guests

The list is long and the names illustrious; Hesse has no less than 32 spa towns. Among them is Bad Nauheim, in itself a work of art, with the spa buildings, park, town and surroundings so perfectly attuned it's as if they were made for one another. And then there's the capital of the federal state, Wiesbaden. The first ruler may have only taken up office in the then duchy of Nassau in 1806 but as a spa Wiesbaden had been popular for 2,000 years. The Roman legionaries stationed in cold and inhospitable Germania must have felt they were in heaven when they soaked their weary limbs in the hot, healing springs.

At the beginning of the 19th century the princes of Nassau had the baths extended. Under the Prussians Wiesbaden became the Nice of the

North and a spa of world renown. Its many prominent guests included the Russian writer Fyodor M. Dostoyevsky. His sojourn centred less on the remedy of his various ailments, however, than on that of his disastrous financial situation. Instead of taking the waters, in 1865 he gambled away his entire capital. The world of literature profited; Dostoyevsky was forced to borrow money from his publisher and in return produced *The Gambler* in just 26 days. The suspiciously autobiographical novel of self-destruction is set in the fictitious town of Roulettenburg – in which the people of Wiesbaden naturally recognise their own city. But who knows: Dostoyevsky also played the casinos in the spas of Bad Homburg and Baden-Baden … Whether it was the scene of a literary masterpiece or not, Bad Homburg can at least claim to have opened the first casino in the world. And as with anywhere where vast sums of money frequently change hands, calling people's bluff is par for the course. Not everybody is who he or she seems …

This was true of the prince of Bad Homburg, for example. Or at least for the Homburg potentate Heinrich von Kleist put on the stage in 1821 and who was very different from his historical role model. The real Friedrich von Homburg who went to battle at Fehrbellin in 1675 was neither a radiant youth nor particularly steady on his feet, as Kleist would have us believe, as he had broken his right leg when he was a child and lost the left one in the siege of Copenhagen. As the wooden replacement wasn't particularly stylish, he had it done up as befitted his status, earning him the nickname of "Friedrich with the silver leg".

To fly like a bird

Driven by a single vision and with little heed for anything else, the two individuals who lived atop the barren, storm-lashed and snowy Wasserkuppe, the highest mountain in the Hessian Rhön (950 metres / 3,120 feet), were like men possessed. Their humble shack was a wardrobe installed in a tent which acted as a workshop – for flying machines. For Alexander Lippisch and Gottlob Espenlaub, no effort was too great, no sacrifice too hard to bear. Even when their tent was replaced by a barracks, in

17

1920 five intrepid "Rhön Indians", as they were known, spent a long and icy winter here.

Lippisch remained dedicated to flying all his life. Among other things he built the Messerschmitt Me 163 and later various military planes for the Americans. Not to forget the legendary glider, the Ente or duck that Fritz Sammler took up into the air in 1928 from the Wasserkuppe – armed with two rockets. In 1970, the official 50th anniversary of gliding, everything came full circle with a visit from Neil Armstrong, forging the ultimate link between the first man-powered rocket and man's first journey to the moon.

At the museum of gliding on the Wasserkuppe, the largest of its kind in the world, you can admire not just the Ente but also many other famous planes which have achieved great things, broken several records and generally made their mark on the history of gliding. One interesting section is even devoted to the evolution of the model plane.

Yet the Wasserkuppe not only enjoys a turbulent past; aviation is still very much a thing of the present here. The gliders now have to share their mountain with small motorised aircraft, however, and also with hang-gliders and paragliders. There is also the model plane brigade, making the skies above the Rhön pretty busy on a clear, sunny day.

Incidentally, in winter you no longer have to brave the cold tinkering away in a wardrobe. Instead you can wrap up warm in your ski suit and enjoy the four ski lifts and half-pipe that make the Wasserkuppe a popular winter resort.

City of art

In Kassel time is measured in two different ways. There's the conventional method dating from the birth of Christ – and then there's the time scale beginning in 1955, when the first documenta exhibition opened its doors wide to contemporary art.

The former royal residence was not only home to (24) princes but also to the Muses, even in the old days. Their most beautiful abode, Schloss Wilhelmshöhe, is a spectacular fusion of architecture and garden design. Here, it's easy to forget that Mars, the god of war, also wrote a devastating chapter in Kassel's history when on 23 October 1943 British bombers started an inferno which almost completely devoured the entire city.

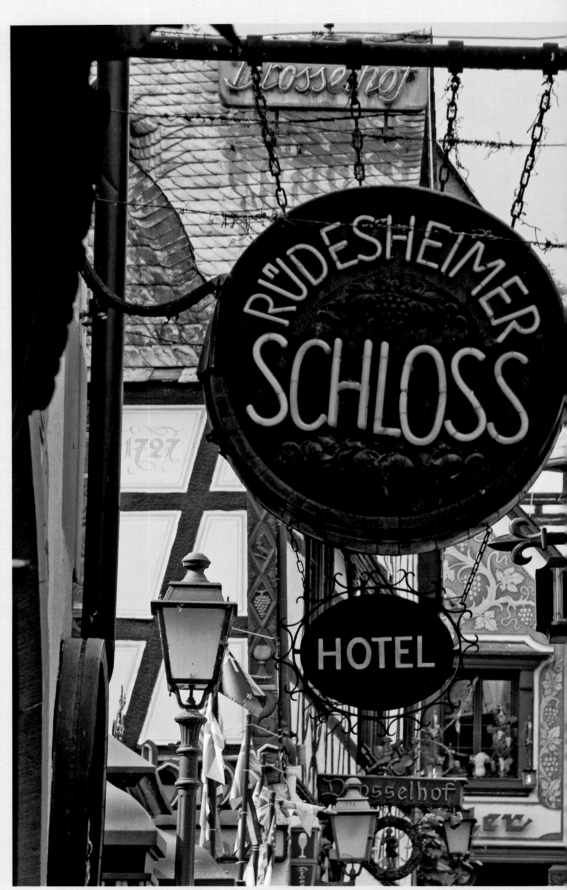

The first documenta that Arnold Bode initiated on the occasion of Germany's national garden show pumped new impetus into the severely damaged city. His prime concern was to heal the mental scars people had suffered when they were alienated from their most significant artists.

With the focus initially on the *entartete Kunst* or degenerate art of the 1920s and 1930s, the following exhibitions increasingly centred on European and later intercontinental contemporary works. documenta, staged every four and then every five years, became an international show. In 1955 it attracted 130,000 visitors; in 2007, this number had risen to almost 755,000. The exhibition area also grew and the Fridericianum Museum breathed a sigh of relief when documenta moved to the hall especially built for it in 1992. Some of the exhibits weren't destined for display in doors anyway. One of these was the bold landscaping project Joseph Beuys instigated for documenta 7 in 1982 under the title of *Stadtverwaldung statt Stadtverwaltung* (city arboretum instead of city administration). Planted in time for documenta 8 in 1987, despite hefty protest, his artwork 7,000 *Eichen* (7,000 oaks) is now generally popular.

On a final note, the first laser installation worldwide in a public city space is also a product of documenta: the Kassel Laserscape from 1977.

Welcome to the centre of Germany

When at the end of the Second World War the American military government founded the greater state of Hesse, not even its citizens really knew who was part of it and who wasn't. This new political construction just seemed to be another stage in the centuries-old monopoly, in which the various regions, cities, villages and their inhabitants were repeatedly shifted back and forth. The only constant was the name of the state – and not what it stood for. Yet the people of Hesse, who since the Carolingians and the Staufer have seemed destined to be at the centre of Germany, have adapted, seeing both the disadvantages but also the advantages of their position. This makes them open on all fronts, ready to embrace innovation and new perspectives. Their success – the evolution of the Rhine-Main conurbation, for instance – backs up this philosophy.

The contrast between the dense population and economic intensity of the south and the peaceful ethnicity of the north is what makes this state so interesting. Within a relatively small area (21, 114 square kilometres / 8,152 square miles) it not only has a wealth of scenic and architectural gems to offer but also plenty of leisure activities.

The Edersee, formed when a dam was built between 1908 and 1914, is one of the largest artificial lakes in Germany. With an area of almost 12 m² (5 sq miles) it's an eldorado for hobby sailors. Motor boats are, however, forbidden here.

Nature's most generous gift to Hesse are the forests. Here there are more than in any other federal state. The many geographic designations – Reinhardswald, Habichtswald, Westerwald, Kellerwald, Kaufunger Wald, Schlierbachswald, Seulingswald and Odenwald, *Wald* being the German for "woods" or "forest" – illustrate this loud and clear.

It only remains to say that in Hesse hikers, joggers, cyclists, horse riders, mushroom, berry and wild herb gatherers, fairytale enthusiasts, castle fans and various other romantic dispositions are perfectly catered for. Water sportsmen and women are also in their element, with the Rhine, Main, Lahn, Fulda and Werra rivers and one of the biggest reservoirs in Germany, the Edersee, at their disposal.

Page 22/23:
The buildings and historical objects spanning four centuries at the Hessenpark open-air museum near Neu-Anspach transport visitors back in time. Alongside its architectural monuments the park also illustrates how people used to live and work. There are also several hostelries catering for hungry cultural explorers.

Page 24/25:
After the medieval Mauritiuskirche burned down in 1850 Wiesbaden needed a new main Protestant church. Carl Boos was thus charged with the construction of the new Marktkirche, also known as the State Cathedral of Nassau. The neo-Gothic edifice, whose steeple rises 98 metres (322 feet) up towards the skies, was consecrated in 1862.

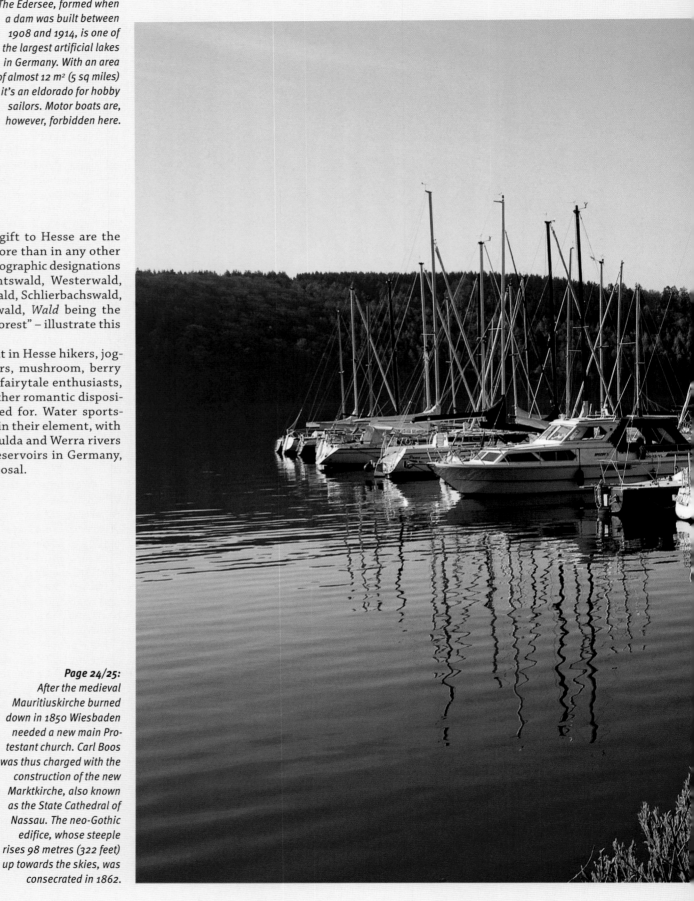

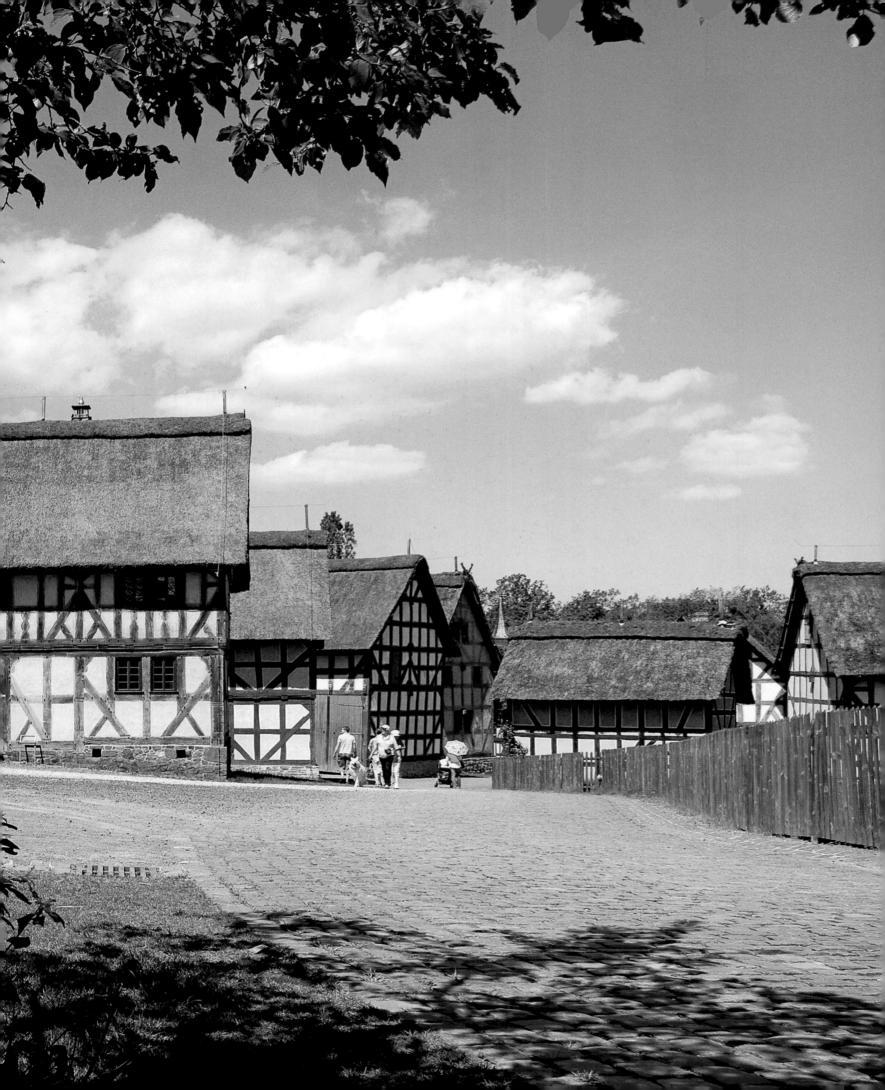

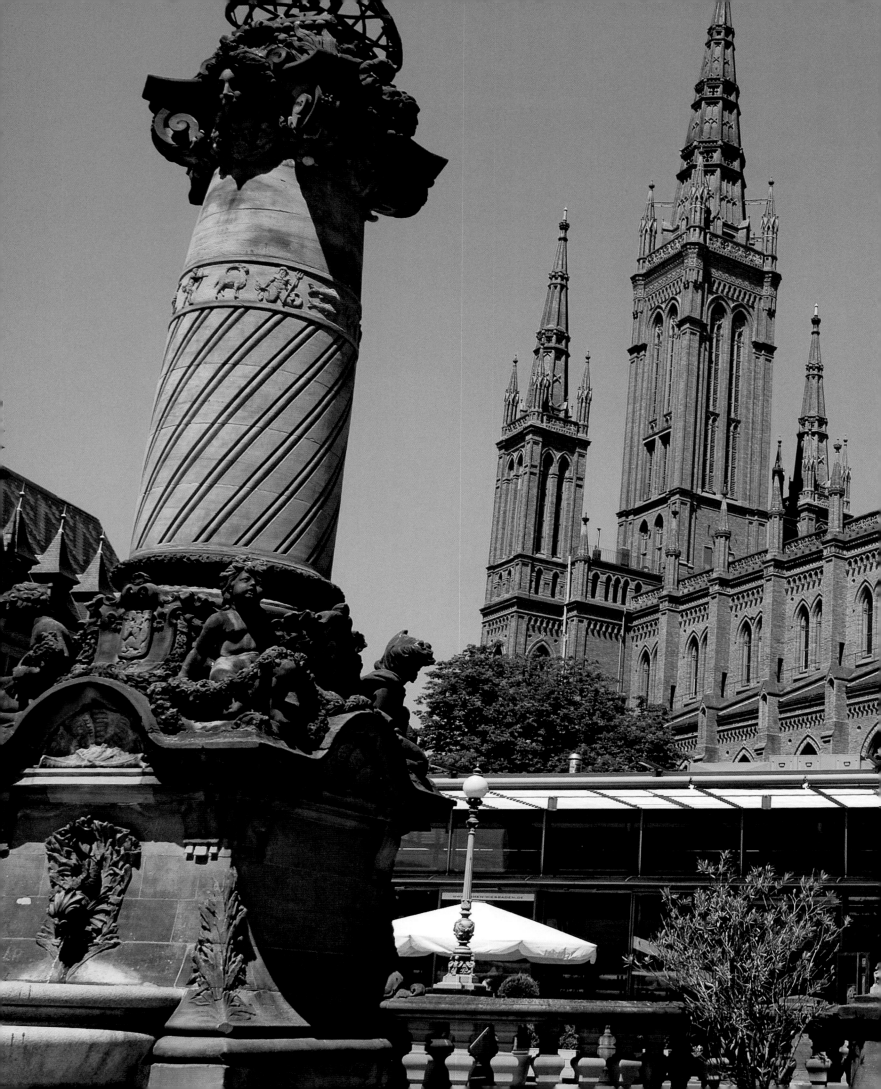

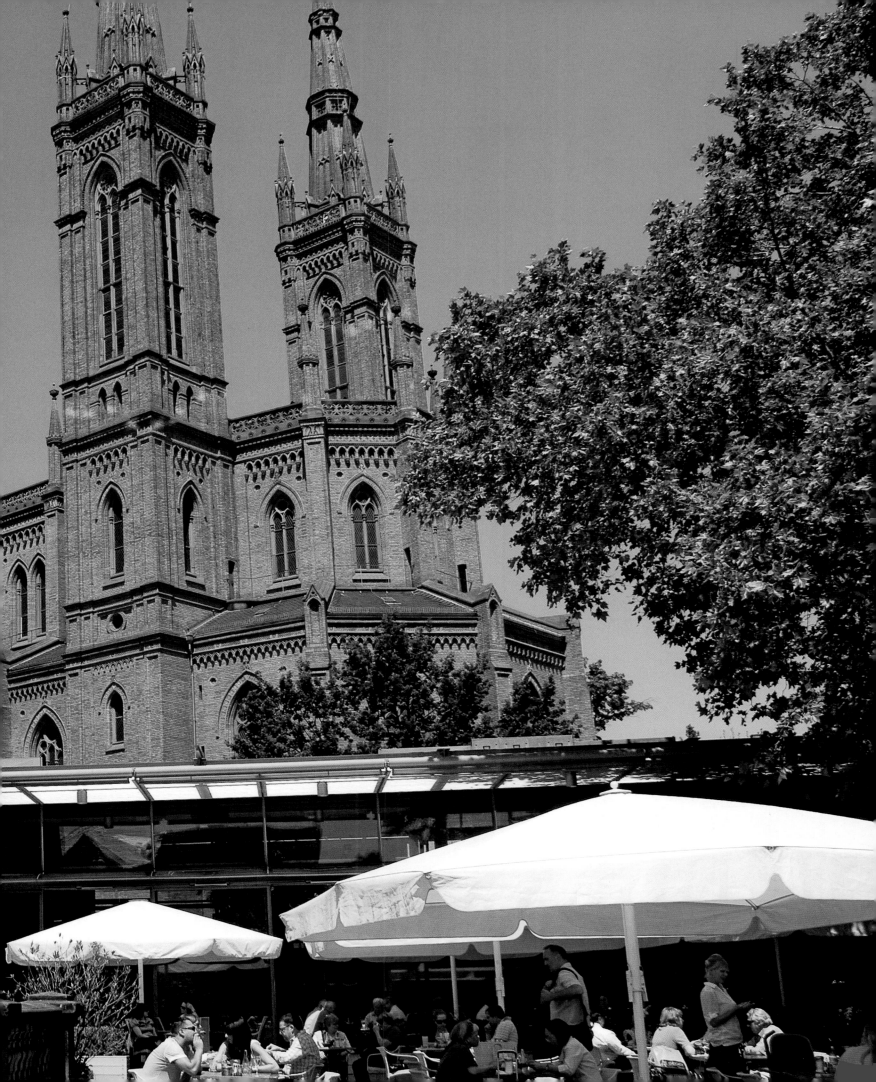

The four castles up above the little town of Neckarsteinach go back to Bligger von Steinach and his heirs. The bold knight who lived at the turn of the 12th century was not only famous for his fortifications but also for his minnesong or love poetry. We can admire his miniature in the *Codex Manesse*, the most comprehensive manuscript of Middle High German *Minnesang* to have survived, as he dictates one of his stanzas. His colleague Einhard, who preceded him by about four centuries and was a close consort and biographer of Emperor Charlemagne, built even more. His architectural legacy includes the basilicas in Michelstadt in the Odenwald and in Seligenstadt, then known as Obermühlheim. It was here, in the largest place of worship to survive from the Carolingian period, that he found his final resting place. Further north is the Wetterau, fertile loess country where people settled as far back as in the Palaeolithic Age. The area was later of strategic importance to the Romans and the Staufer dynasty. The ground plan of Friedberg Castle, for example, one of the largest medieval strongholds in Germany, is that of a Roman fort. Remains of an ancient hypocaust or underfloor heating system have also been found here. Near Usingen in the Taunus Mountains archaeologists have unearthed a sizeable military base known as the Saalburg where in the 3rd century AD 600 legionaries manned the Roman line of defence, the Limes.

Compared to the Romans, the queen of flowers conquered the Wetterau at a relatively late stage in our history. In 1868 Heinrich Schultheis opened the first German rose nursery in Steinfurth which has since made the village that is now part of Bad Nauheim famous well beyond its national boundaries.

Right:
The idyllic Odenwald near Lindenfels, formerly an administrative centre of the Electoral Palatinate. The town was first mentioned in 1123 as belonging to the monastery at Lorsch and is now an official health resort, visited for its curative climate.

Below:
The Otzberg in the Odenwald is crowned by a fortress erected by Fulda at the end of the 12th and beginning of the 13th centuries. Once it had lost its military importance it was first used as a state prison and then a youth hostel. It now accommodates a museum of local costume and customs.

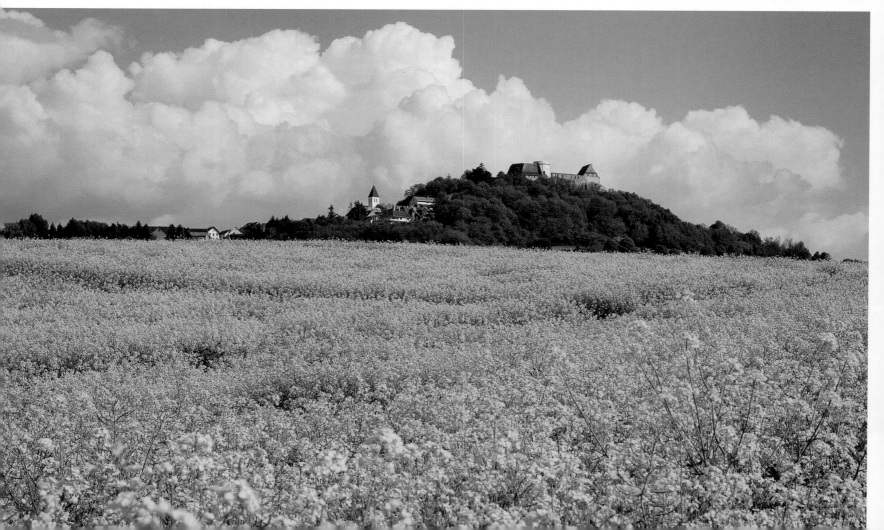

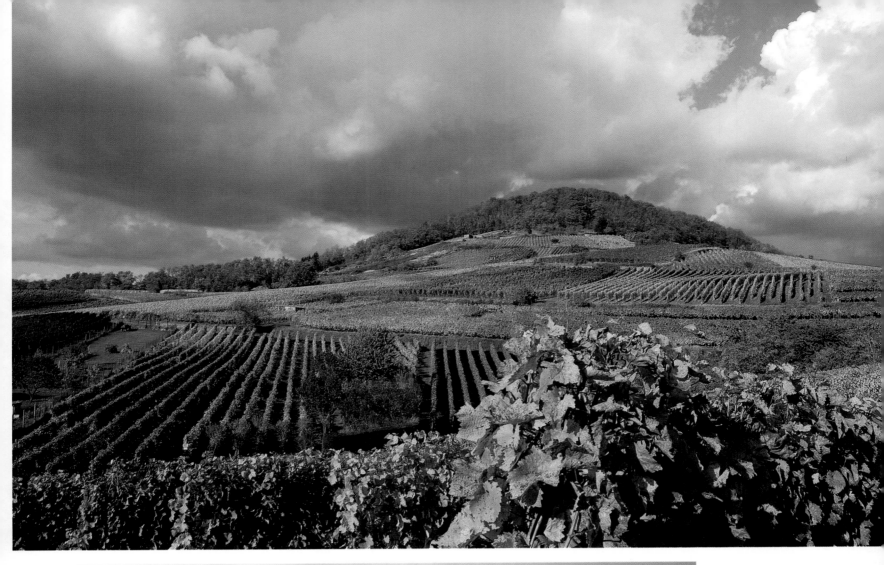

Above:
Vineyards on the Berg-straße, the produce of which is best drunk on site. One such opportunity is presented by the Wein-markt in Heppenheim that takes place every last weekend in June and last for nine days.

Left:
Even if spring is greeted by much celebration on the Bergstraße, ice and snow are not infrequent, such as here near Heppenheim. The winters are usually fairly mild, however, and the cold less severe than in other parts of the country.

29

Left:
From the ruins of the Auer-bacher Schloss there are grand views out across the countryside. The mighty defences were once in the hands of Lorsch Monastery. They later fell to the counts of Katzen-elnbogen and then to the landgraves of Hesse. Destroyed in the Franco-Dutch War in 1674, the castle is now also popular for its pub-restaurant.

Centre left:
Sights such as this used to be extremely familiar in the Odenwald. Today charcoal heaps are only fired as a hobby on special occasions and at local festivals.

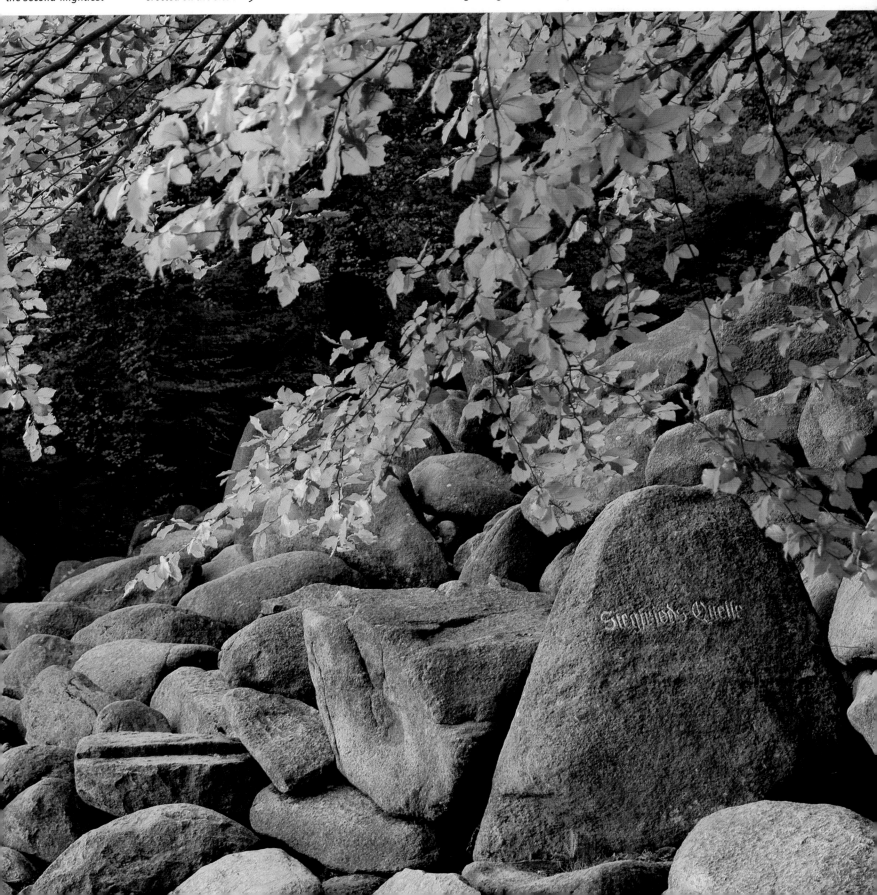

Bottom left:
The origins of Starkenburg Castle up above Heppenheim go back to the middle of the 11th century. Once the second-mightiest stronghold held by the electorate of Mainz, in the mid-18th century it was abandoned and left to decay. A youth hostel was erected on the site in 1960.

Below:
Legend has it that the wild, rocky landscape near Lautertal-Reichenbach was formed during a stone-throwing match between two belligerent giants; geologists believe that it's the result of weathering. Many finds indicate that the dark grey quartz diorite was once mined by the Romans. The Siegfriedquelle hidden amongst the rocks is allegedly the spring where Siegfried was murdered in the Song of the Nibelungs. However, there at least five villages in the Odenwald who make a similar claim ...

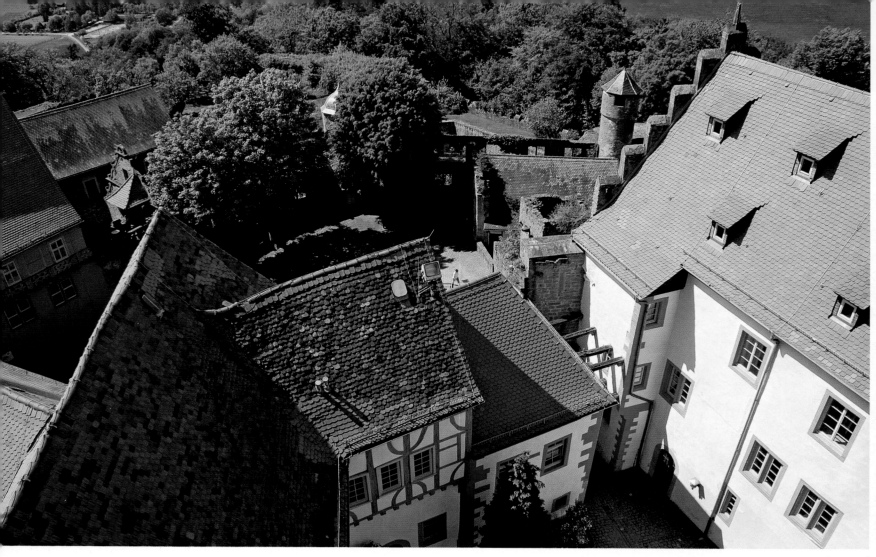

There's also a youth hostel at Burg Breuberg, plus a restaurant and a museum. The core of the castle dates back to the 13th century. Much of its 16th-century fortification was the work of Count Michael II of Wertheim; Count Johann Casimir of Erbach later had the outer bailey splendidly extended at the beginning of the following century.

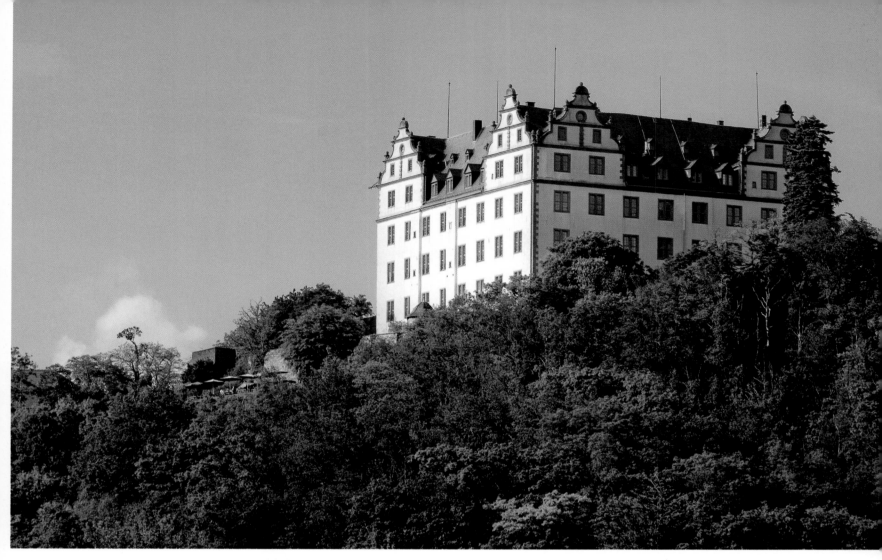

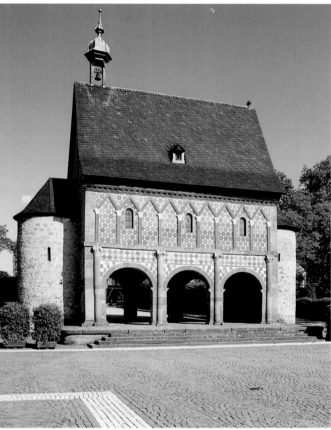

Above:
Once a medieval castle,
Schloss Lichtenberg was
later turned into a fortress
that was never taken.

Far left:
The spring of the Mümling
in the heart of the little
town of Beerfelden was
redesigned following the
great fire of 1810.
The fountain was a major
source of drinking water
for the local populace at
the end of the 19th century.

Left:
This magnificent
monument to Carolingian
architecture at the
monastery in Lorsch was
long thought to be just a
gateway. However, it also
could have been erected by
Emperor Charlemagne as
an imperial hall in view of
his impending coronation.

Left page:
The main building of the old town hall in Erbach goes back to the mid-16th century, with the gateway finished at the end of that century. The Altes Rathaus is now a tourist centre for the Odenwald. Behind the building is the steeple of the Protestant town church, erected between 1747 and 1750.

Erbacher Schloss was built by Count Georg Wilhelm and its collection of Antique relics, weapons and much more compiled by his son Franz (1754–1823). Franz also made a name for himself as an archaeologist and initiator of Erbach's famous ivory carvings.

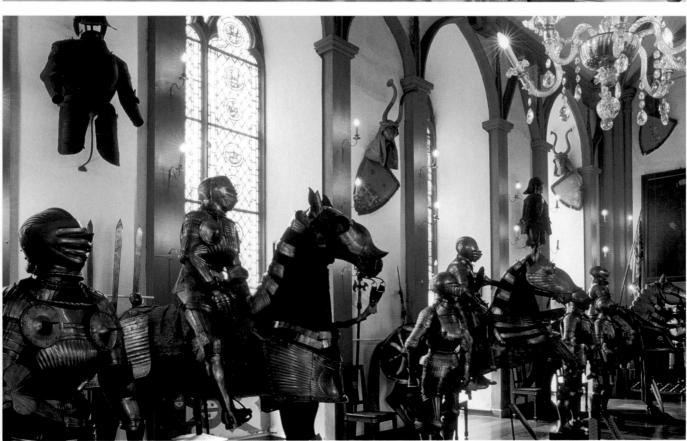

35

Images of Groß-Umstadt. In the foreground is the fountain crowned with an allegorical figure holding a palm leaf and two coats of arms. On the left is the Renaissance town hall from the beginning of the 17th century and to the right the Protestant church with its 13th-century steeple.

Right page:
One of the highlights of Michelstadt's local calendar is the Bienenmarkt or bee market at Whitsun. In the background is the half-timbered town hall from 1484, one of the most beautiful and well known in Germany, so much so that it has even been featured on a stamp.

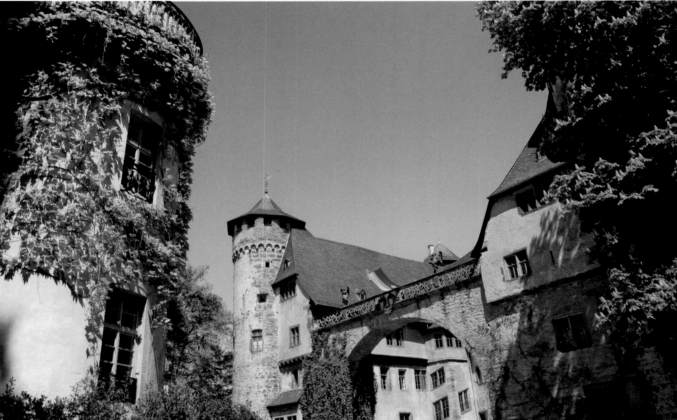

The water that turns Fürstenau in Steinbach (now part of Michelstadt) into a moated castle is provided by the River Mümling. Probably erected by the arch-convent of Mainz in the early 14th and refurbished in keeping with more modern tastes in the 15th and 16th centuries, it later fell to the lords of Erbach whose descendants still live here.

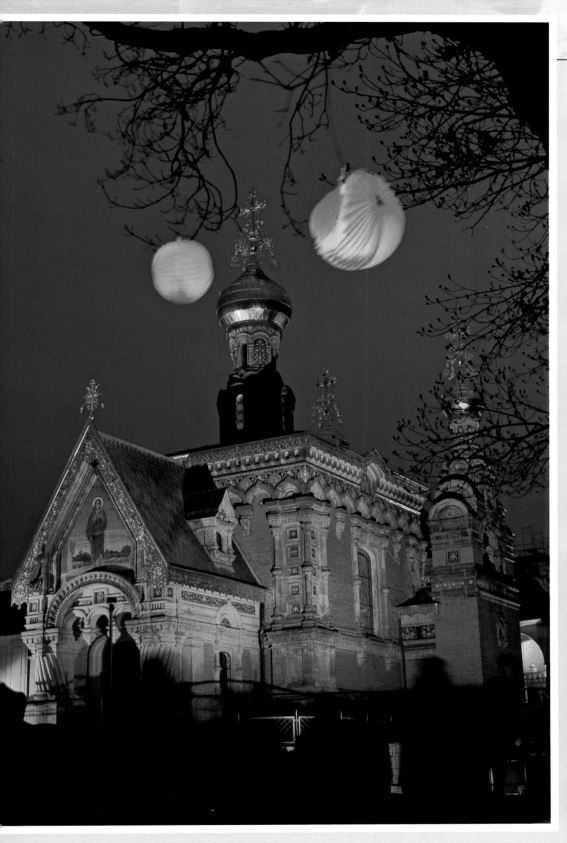

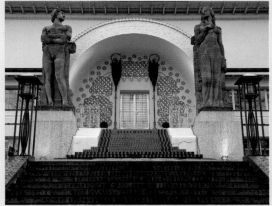

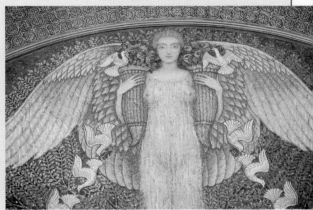

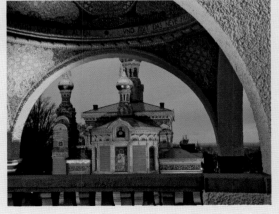

Small photos, right, from top to bottom: Entrance to the Ernst Ludwig Haus. To quote Prof G Kiesow, "The pathos that lingers in the monumental statues is a Historicist inheritance."

Friedrich Wilhelm Kleukens (1878–1956), artistic director of the famous Ernst Ludwig Presse, called the two mosaics in the Wedding Tower entrance hall Loyalty and The Kiss.

View of the Russian Chapel from the exhibition hall built in 1908 for the Hessian State Exhibition for Free and Applied Art.

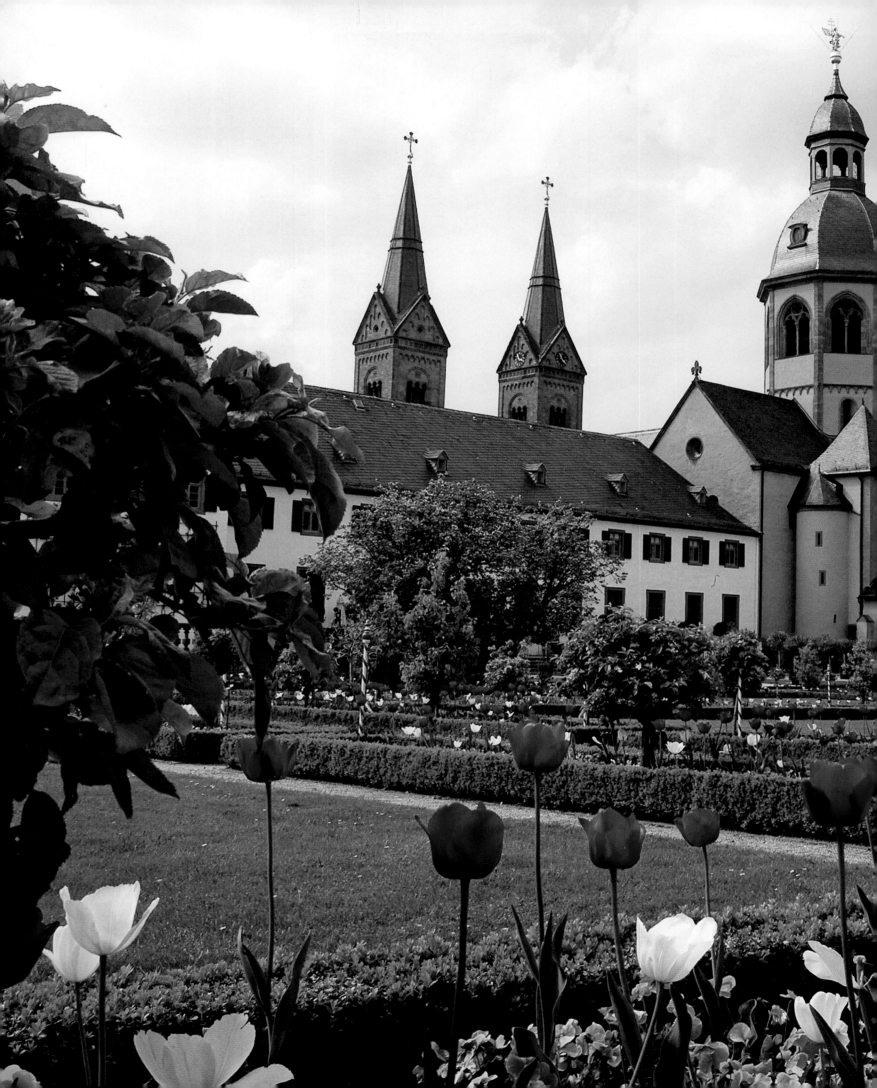

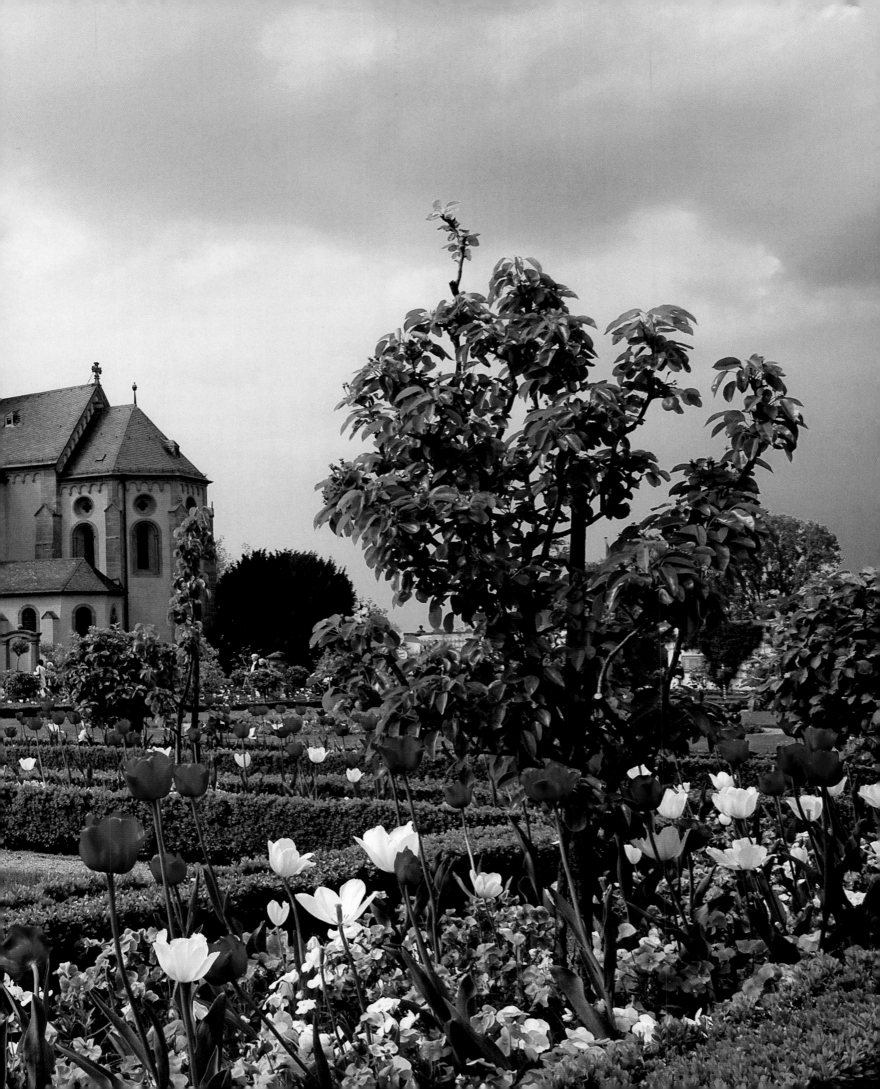

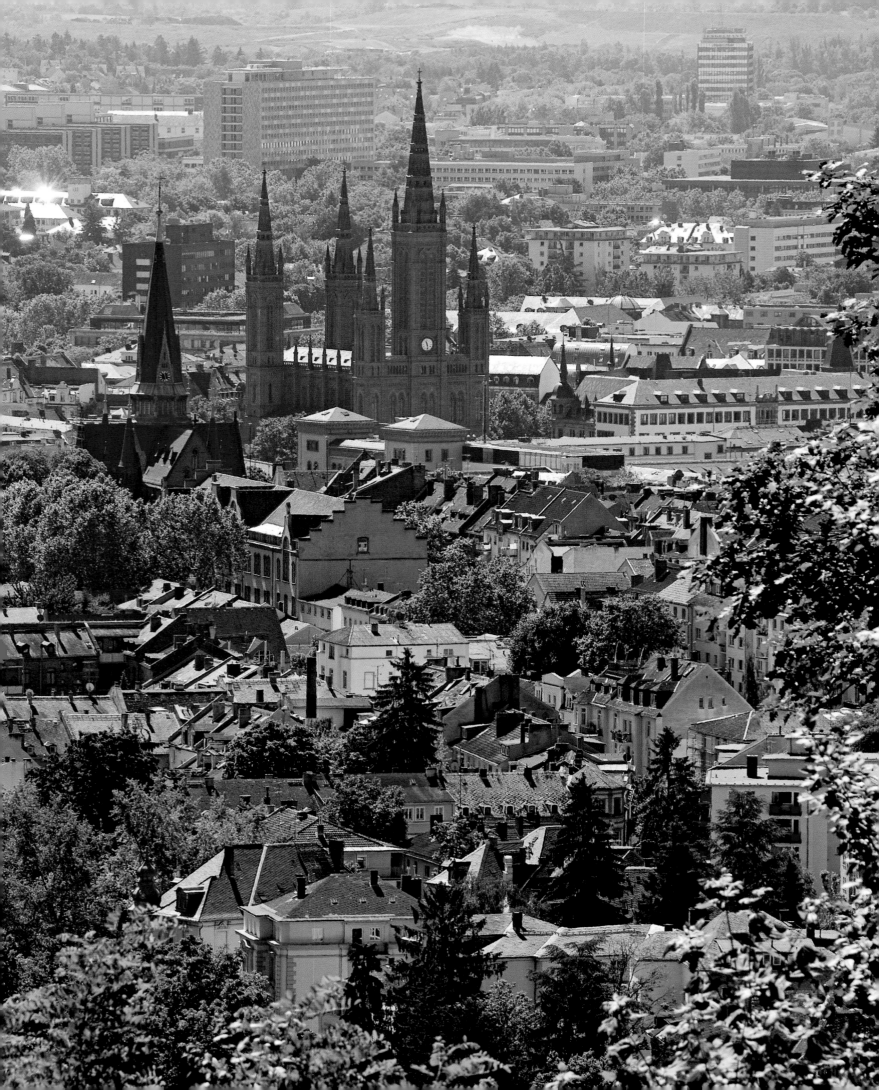

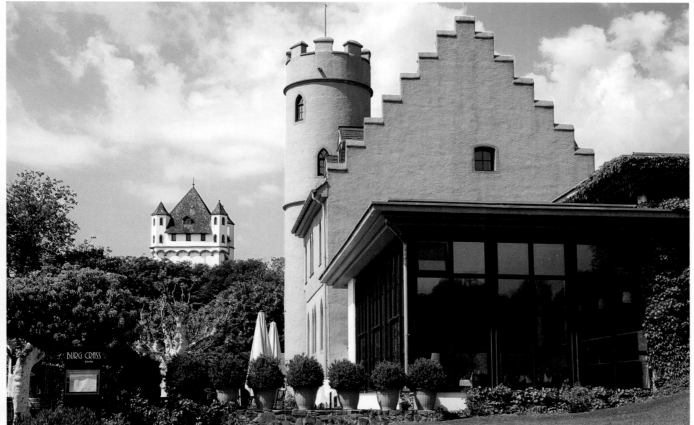

Above:
This building in Eltville was put up in c. 1830. It was first a house, then a seminary for talented young musicians and later used for receptions and champagne tasting. It was owned by Matheus Müller, the founder of the famous Mumm brand of sparkling wine, which became part of the Rotkäppchen-Mumm Group in 2002.

Left:
Eltville on the Rhine. In the foreground is the neo-Gothic Burg Crass, with the 14th-century tower of the elector's castle in the background. The town's famous landmark now harbours a memorial to famous printer Johannes Gutenberg.

Below:
As this photo shows, taken high up above Rüdesheim, this region is largely given over to wine-growing, with the climate of the Rhine Valley extremely favourable.

Top right:
The neo-Romanesque Benedictine convent of St Hildegard's in Eibingen, built at the start of the 20th century, is the succes- sor both in name and function of the nunneries of Rupertsberg and Eibingen founded by St Hildegard of Bingen in the 12th century.

Centre right:
The metal Germania that crowns the Niederwald-denkmal is 10.5 metres (34 feet) tall and weighs 32 metric tons. The monu-ment was erected in a fit of patriotism on winning a victory over France in 1870/71, prompting the refounding of the German Empire.

Bottom right:
View of the Rhine near Rüdesheim. The shore and islands between Eltville and Bingen are a pro-tected European nature reserve and an important place of hibernation and rest for migratory birds.

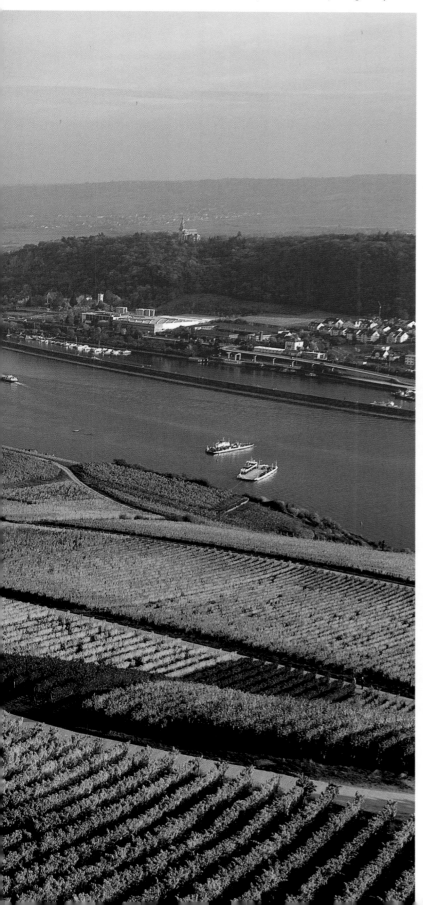

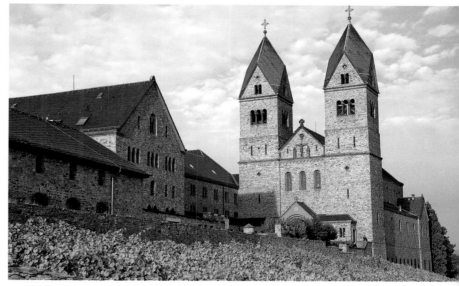

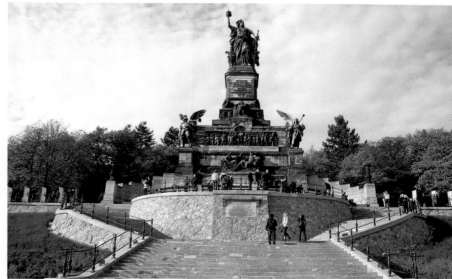

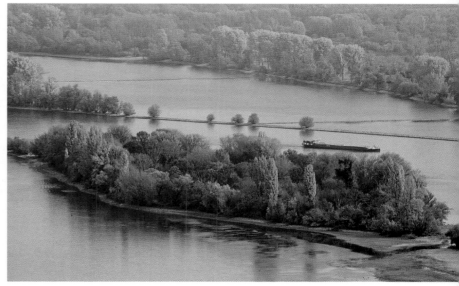

ROMAN WINE COUNTRY – THE RHEINGAU AND HESSISCHE BERGSTRASSE

The fact that Bacchus can run one of his most famous wine estates worldwide in the Rheingau is largely thanks to the existence of the River Rhine. Otherwise known for the directness with which it flows towards the North Sea, between Walluf and Lorchhausen the great waterway has to take a detour around the hills of the Taunus. In doing so, its southern shores are exposed to the sun, with the water acting like a giant reflective mirror. The soil is also good here, nurturing the vines on a diet of quartz, sandstone, gravel and loess, providing ideal conditions in which local wines positively thrive.

Riesling is the number one grape here, both in quantity and quality. It's also one of the older and more venerable species of *vinum*, with the most famous vineyards including Gräfenberg near Kiedrich, Steinberg not far from Kloster Eberbach and Johannisberg. This is where is 1106 the Benedictines first came into contact with wine. The year 1775 is of even greater significance, however. When the messenger finally arrived with the bishop's order to start harvesting the grapes, they were mouldy. The harvest was thought to be lost. Imagine the vintner's surprise and glee when the first bottles of *Spätlese* or late harvest wine were opened and found to be extremely tasty!

The Rheingau is not only famous for its Riesling but also for its good Spätburgunder or Pinot noir. The best known red wine village is Assmannshausen with its Höllenberg vineyard. Although the name means "hell mountain", this is totally inappropriate when it comes to wine as the vintages its slate slopes produce are very fine indeed. The Romans were the first to grow grapes in the Rheingau, a tradition Charlemagne enthusiastically continued. The emperor had local winegrowers not only tend the vines but also allowed them to sell some of their yield, earning him the credit for the birth of the *Straußwirtschaft* or wine tavern, among his many other claims to fame. At the beginning of the 12th century the Cistercians at the monastery in Eberbach proved to be pioneers in the field, pumping new impetus into the art of winemaking. The motivation of their 'staff' was so important to them – and to monks at other monasteries – that they released them from serfdom. This is encapsulated in a local saying, "Rheingauer Luft macht frei" – or in English, "the air of the Rheingau is liberating". Literally so.

The fine difference

The vineyards lining the Bergstraße that fell to the new federal state of Hesse were almost ascribed to their big brothers in the Rheingau. In the end it was the wine experts who won the fight with the bureaucrats – and rightly so. Although the Riesling wines of the Bergstraße and those of the Rheingau are practically neighbours, they are very different in character. The wines from Heppenheim, Bensheim and Zwingenberg are more delicate and of a crisper acidity than their Rheingau competitors. Many of them are also said to have a more earthy note caused by the local *terroir*, namely weathered rock and fertile loess.

As opposed to the 3,000 hectares or 7,500 acres of vineyard in the Rheingau, Bacchus' terrain on the Hessian Bergstraße is much more modest. Of his German dominions, only those on the Saale and Unstrut rivers and on the Elbe in Saxony are smaller. Riesling is also predominant on the Bergstraße but leaves some room for Müller-Thurgau and Silvaner – and is becoming increasingly more tolerant of its cousins Weißburgunder (Pinot blanc) and Grauburgunder (Pinot gris).

The vineyards cover an area of no more than 5,000 square metres or ca. 54,000 square feet. The wine is cultivated by part-time growers. Even if with a bit of luck and careful research you can buy Bergstraße wine in the shops, bottles from the Odenwälder Weininsel, an enclave surrounding the town of Groß-Umstadt to the northeast, are only available on site. The best time to taste them is during the Odenwald wine festival which takes place every year on the first weekend after 15 September and is well worth a visit.

Left:
The contents long since drunk, this wine barrel and cart make an attractive and topical arrangement under the shady trees.

Above:
Geometrical vineyards on the Bergstraße. There hardly seems to be a leaf out of place ...

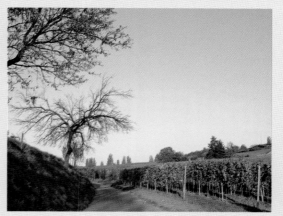

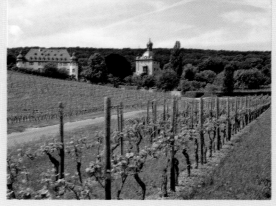

Small photos, right, from top to bottom: Philologist and writer Karl Simrock (1802–1876) considered Johannisberg and its vineyards to be one of "the most joyful, most lovely of all German pastures".

Vineyards near Heppenheim. Many different grapes are grown here, among them Riesling, Pinot blanc, Pinot gris, Chardonnay, Gewürztraminer and the younger 'immigrants' Müller-Thurgau and Kerner.

Pinot noir, Dornfelder and also St Laurent are among the types of red grape grown on the slopes of the Bergstraße in Hesse.

Schloss Vollrads is one of the oldest wineries in the world, trading in fine vintages since the beginning of the 13th century.

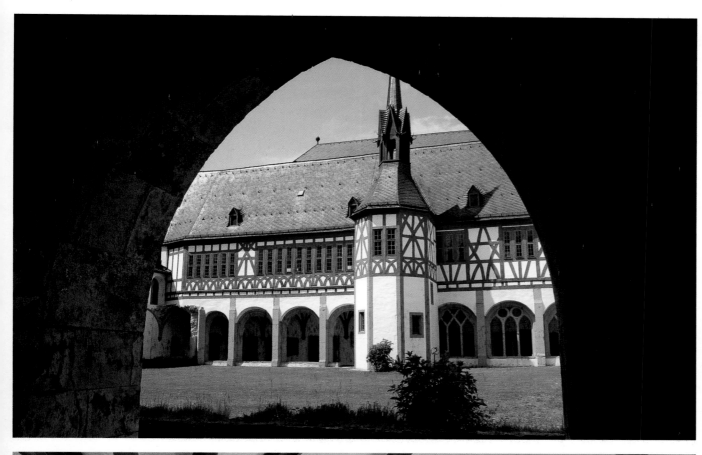

Left page:
The medieval keep, built on Roman foundations, is the oldest part of Schloss Vollrads.

The wonderful buildings of Kloster Eberbach are frequently used for concerts. The former monastery is also home to Hesse's state winery, continuing the long tradition of wine-growing on the ancient estate.

The early Gothic dormitory once used by Eberbach's monks is ca. 70 metres (230 feet) long. The aisled room is divided by pillars adorned with sculpted capitals that bear the weight of an enormous rib vault.

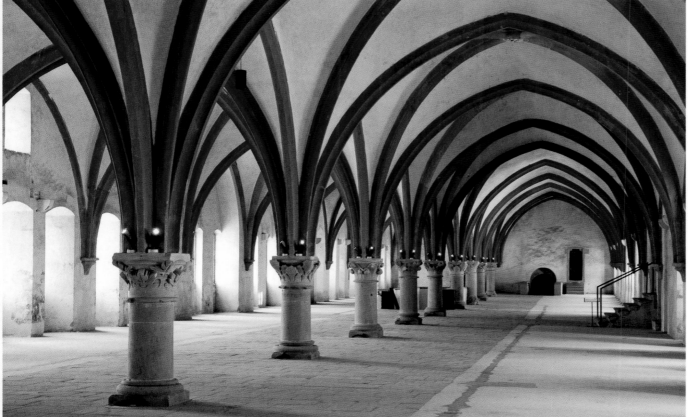

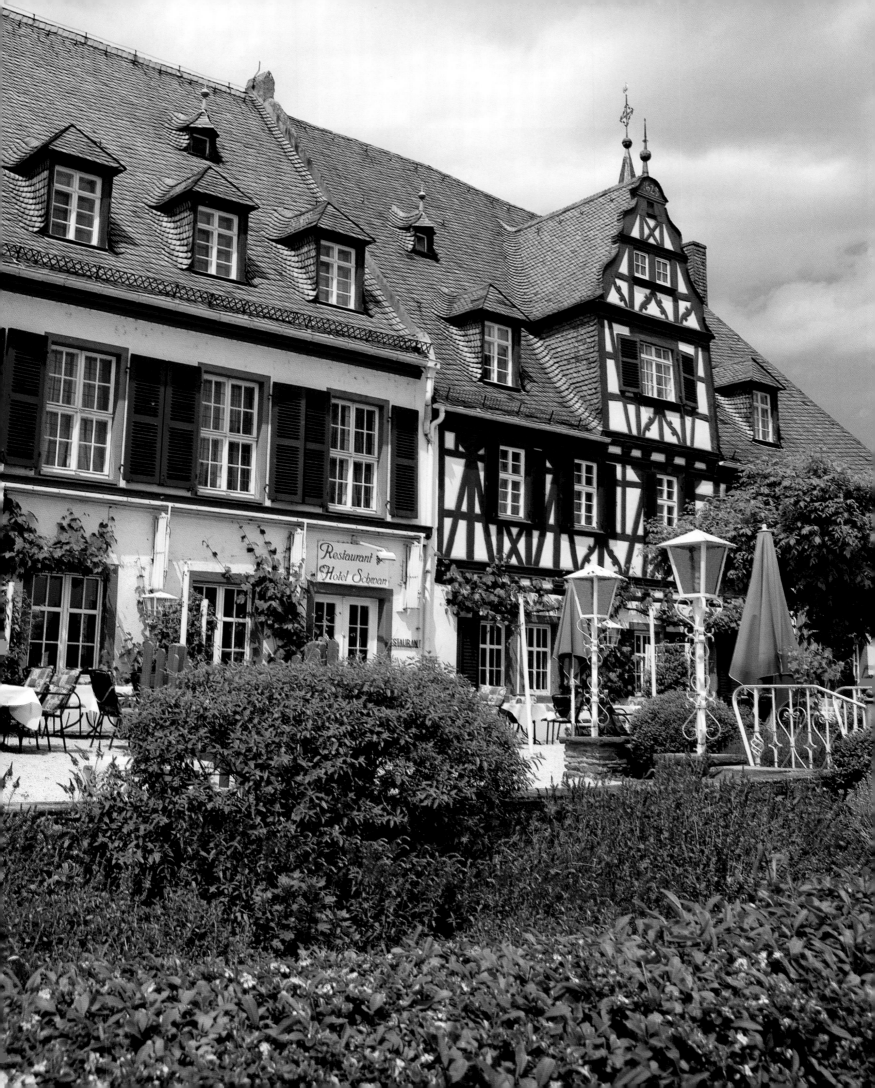

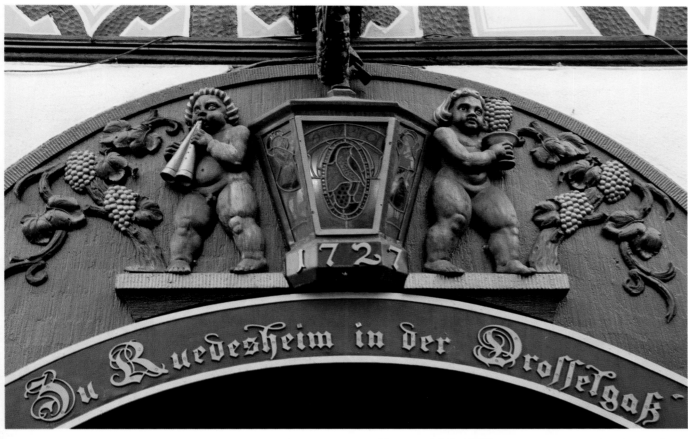

Left page:
The largest wine-growing town in Hesse is Oestrich-Winkel in the Rheingau. It proudly presents its wines at numerous wine festivals, wine estates and wine taverns; the Schwan hotel and restaurant has been welcoming guests since 1628, for instance.

The Drosselhof restaurant in the (in)famous Drosselgasse in Rüdesheim is itself so well-known that Otto Hausmann (1837–1916) once dedicated a poem to it. His ditty, entitled "Zu Rüdesheim in der Drosselgass'", has naturally been set to suitably merry music, with a refrain you can't help swaying or singing along to. Learning the words is easy once you've imbibed a few glasses of the song's subject ... The medieval Brömserhof (bottom right) is one of the few large houses in Rüdesheim that is not a tavern or hotel but is just as charming, with its half-timbered, late Gothic tower, pointed roof and spiked turrets a local landmark. The ancient noble seat is now a museum of mechanical musical instruments.

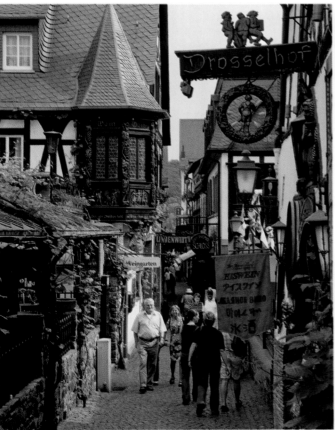

Page 58/59:
Glorious half-timbering in the old town of Bad Orb. The salt springs here have been famous since the year dot, with the production of 'white gold' reaching its peak in the 17th and 18th centuries. The first salt baths were opened in 1837.

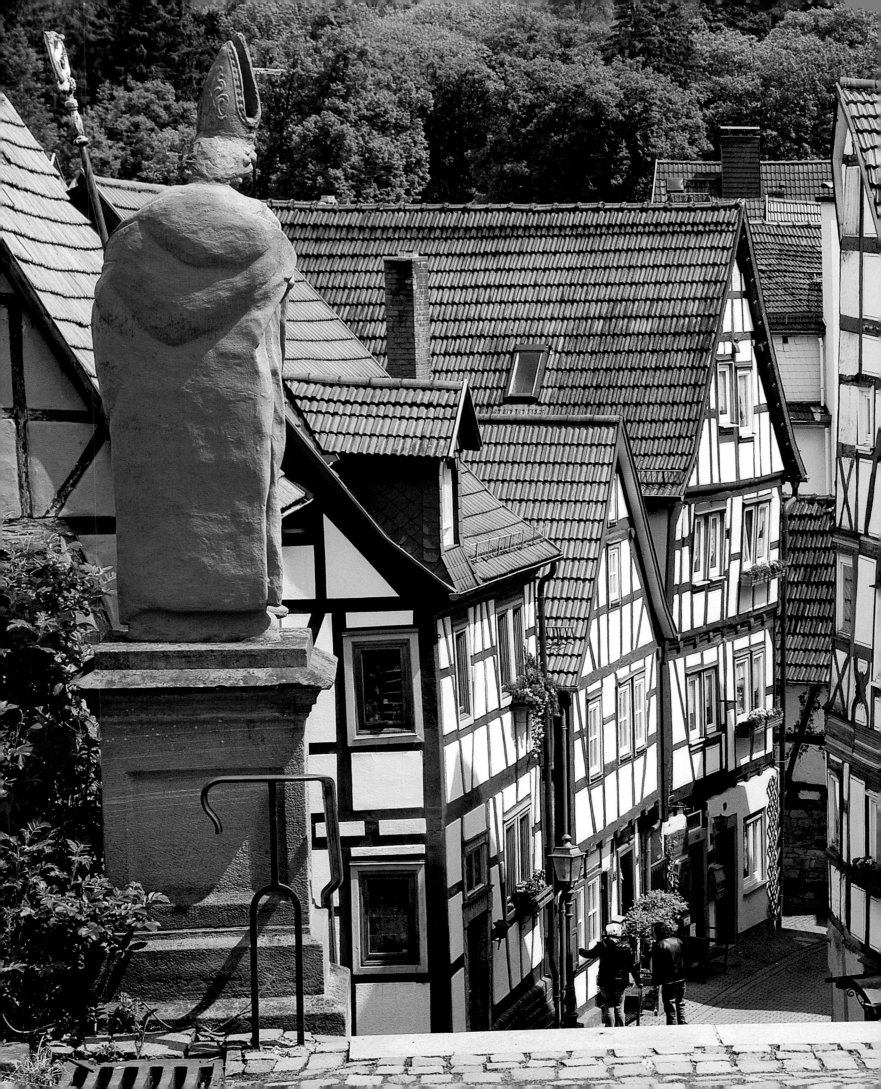

Left page:
Schloss Ramholz in Schlüchtern unites the early 16th and late 19th centuries. Not long after industrialist Hugo von Stumm purchased the old castle from von Hutten in 1883, he had a new one built.

Left:
Burg Schwarzenfels was first mentioned at the end of the 13th century and later turned into a palace. The latter was not destroyed by war but by the Prussians who allowed it to gradually fall into rack and ruin.

Far left:
Near Sinntal, the most easterly community in the Main-Kinzig district, the Spessart and Rhön are very close together.

Left:
Near Friedberg in the Wetterau, famous for its "prolificness of grain, fruit and wine … The earth is pure garden soil and it takes much effort to find a stone in the fields. Rich pastures, planted with fruit trees … hold a charitable appeal for the wanderer." Thus reminisced Ludwig Bocle in 1813, once here on a school excursion.

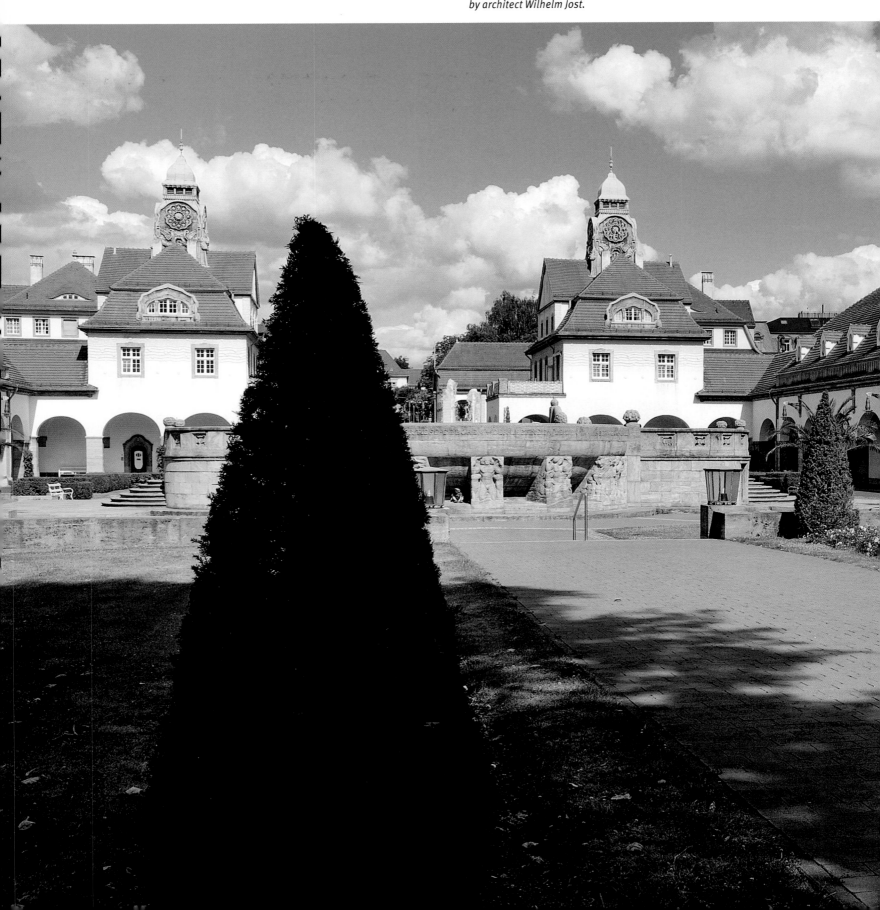

Below:
At first glance the Sprudel-
hof in Bad Nauheim looks
like a baroque palace
but is in fact the largest
Jugendstil spa complex
in Europe. It was built
between 1905 and 1912
by architect Wilhelm Jost.

Top and centre right:
At the graduation works in Bad Nauheim salt water is allowed to dribble down a wooden frame packed with brush; in doing do, the water evaporates and the salt content rises from 3% to 13–16%.

Bottom right:
This fierce lion is just a pussy cat at heart – made of bronze and purely for the delight and delectation of the spa guests in Bad Nauheim.

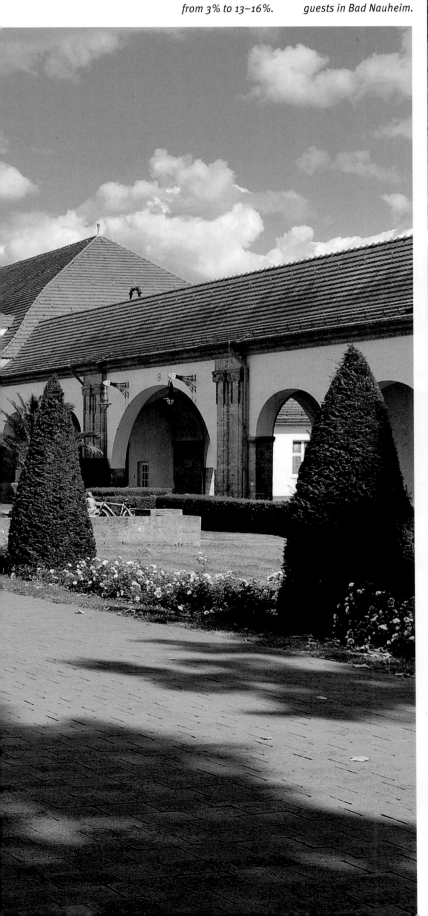

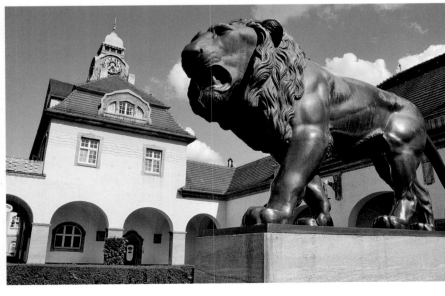

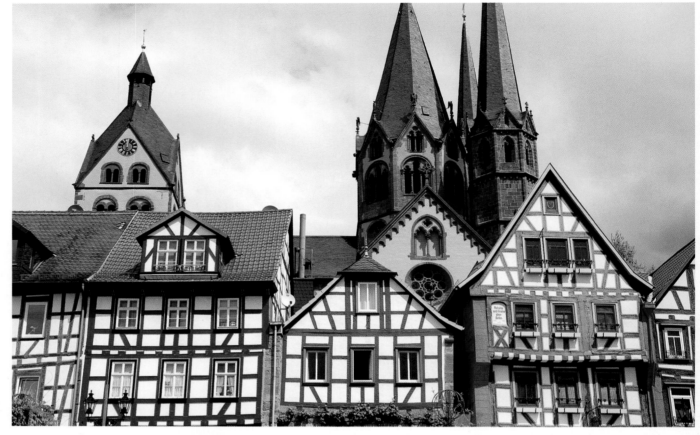

Half-timbering and high turrets in Gelnhausen. The latter belong to the Marienkirche on which construction was started just after 1170 when Emperor Barbarossa granted Gelnhausen its town charter. The town continued to grow well into the baroque period.

The imperial palace in Gelnhausen is one of the most important and beautiful legacies of Staufer rule. The great hall boasts an extremely rich assortment of Romanesque carving otherwise only found in places of worship.

Right page:
The Marienkirche in Gelnhausen has one of the few rood screens to survive from the Middle Ages intact. It was constructed in the first half of the 13th century. The four reliefs in the spandrels depict the Last Judgement.

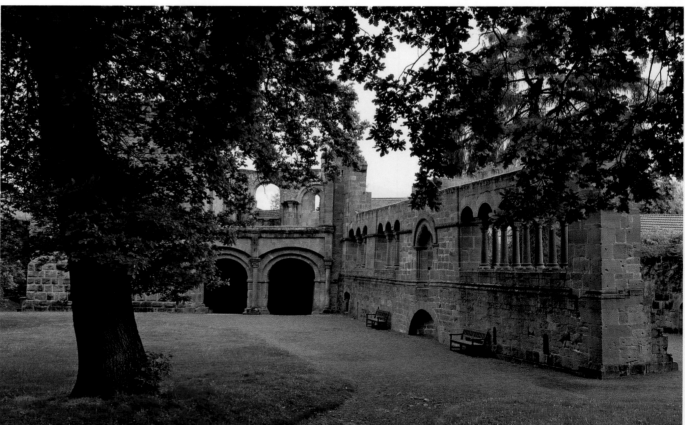

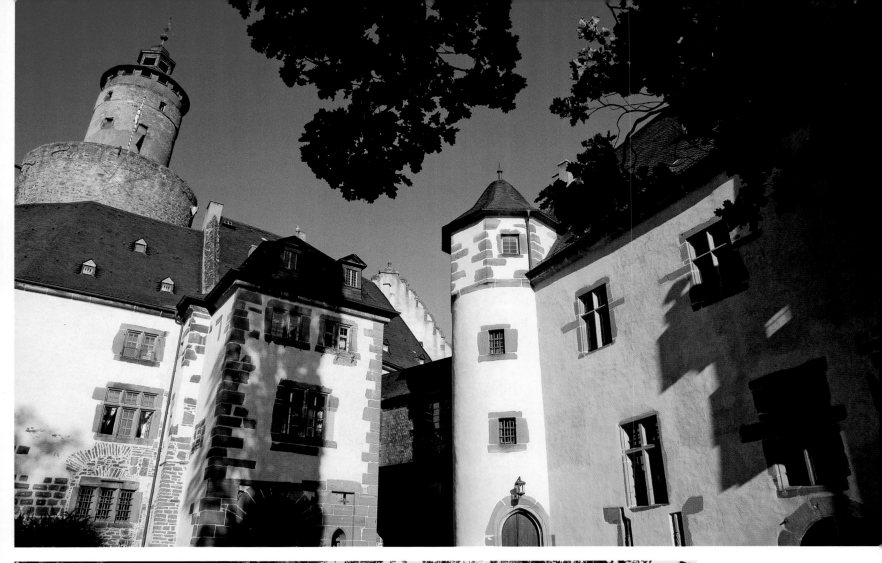

Above:
The castle of the Ysenburgs in Büdingen was once a moated Staufer stronghold of great strategic importance. The keep, chapel and great hall of the early fortress have survived.

Left:
On the left is the Weidig Haus in Butzbach, with the Hexenturm or witches' tower in the background on the right. Friedrich Ludwig Weidig once published the revolutionary pamphlet "Der Hessische Landbote" together with Georg Büchner. Hurled into the dungeons for his democratic convictions, he committed suicide there in 1837.

73

Right:
The most important castle to belong to an imperial Staufer ministerialis or servitor is in Münzenberg. The 'inkpot' of the Wetterau, as it's known locally, is guarded by a mighty curtain wall and no less than two huge keeps.

Below:
Burg Friedberg's remarkable fabric dates from the 14th to the 18th centuries. The little town of Friedberg was not so enamoured with its castle, having spent much of its history battling with the castellans ...

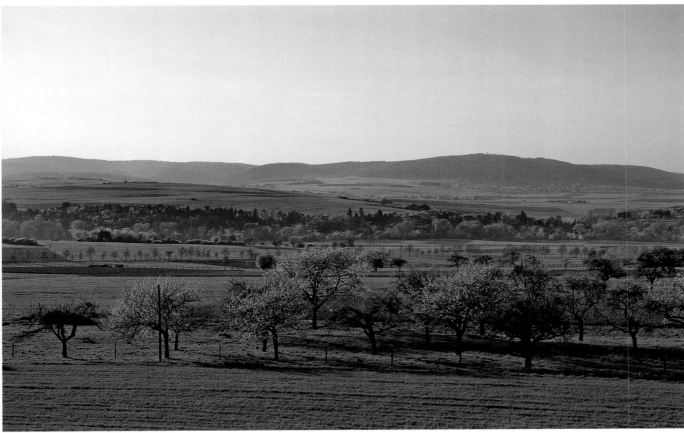

"The Wetterau is nine miles long and wide, reaching in its length from Gelnhausen to Castel on this side of Mainz on the Rhine. In its width [it stretches] from Gießen towards Seligenstadt. The Wetterau is richly blessed by God, for here wheat, beautiful rye, barley, oats, peas, flax and good wine grow well ..." (Erasmus Alberus, "Kurze Beschreibung der Wetterau", 1552).

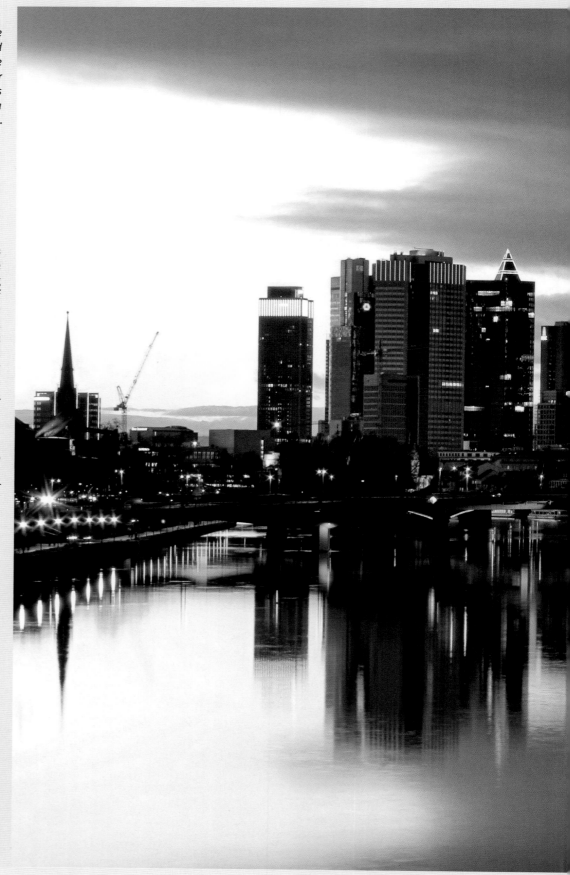

When the hue of the evening sky is reflected with the lights of the skyscrapers in the River Main, Frankfurt looks like something out of a fairytale.

Walking through Frankfurt with Goethe as our guide is hard work. Perhaps even more so than being at the book fair. Or wandering aimlessly for hours through the labyrinth of Frankfurt International Airport. Goethe, as we all know, knew everybody and everything – and is eager to prove it. His birthplace, our first port of call, was rebuilt after the Second World War but the furnishings are original, as they are in the garden house of a certain Mrs von Willemar. Which brings us to the female sex. Johann Wolfgang von Goethe was a bit of a lady's man; Marianne von Willemar, the wife of a banker, was so in love with him that she almost gave up on herself. The great poet himself, it is ambiguously said, always had his emotions under control. Another feminine preoccupation of his was Susanna Margarethe Brandt who was executed at the Hauptwache (our next stop) in 1772. He allowed the child murderer to live on as Gretchen in *Faust*. Goethe was also vain, which is why we have to trot along to the Städelsches Institut to admire the portrait Tischbein painted of him in the Campagna. But that's enough. After all, there's more to Frankfurt than Goethe.

Money, for example. Frankfurt is famous for it; the stock exchange has operated from here since 1585 and many big-name banks, insurance companies and major concerns are based in the city. Their aspirations rise sky-high – literally, with elongated office blocks of all designs and denominations piercing the heavens. This has earned Frankfurt the epithet of Mainhatten – impressive, but still a far cry from the Manhattan it alludes to.

Although the metropolis on the River Main is often its own worst enemy, its verve is indisputable. This is fuelled by its traditional intimate relationship with science, music and the arts which bears some extraordinarily notable fruit, as the museum festival on the banks of the Main demonstrates each and every year.

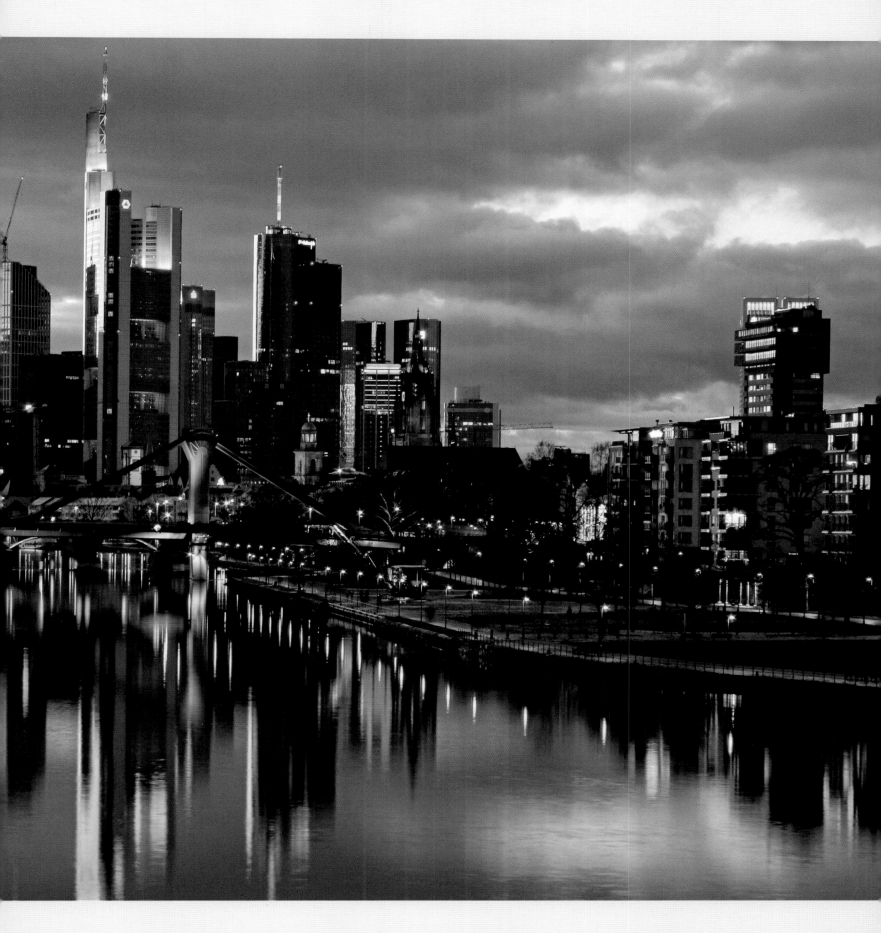

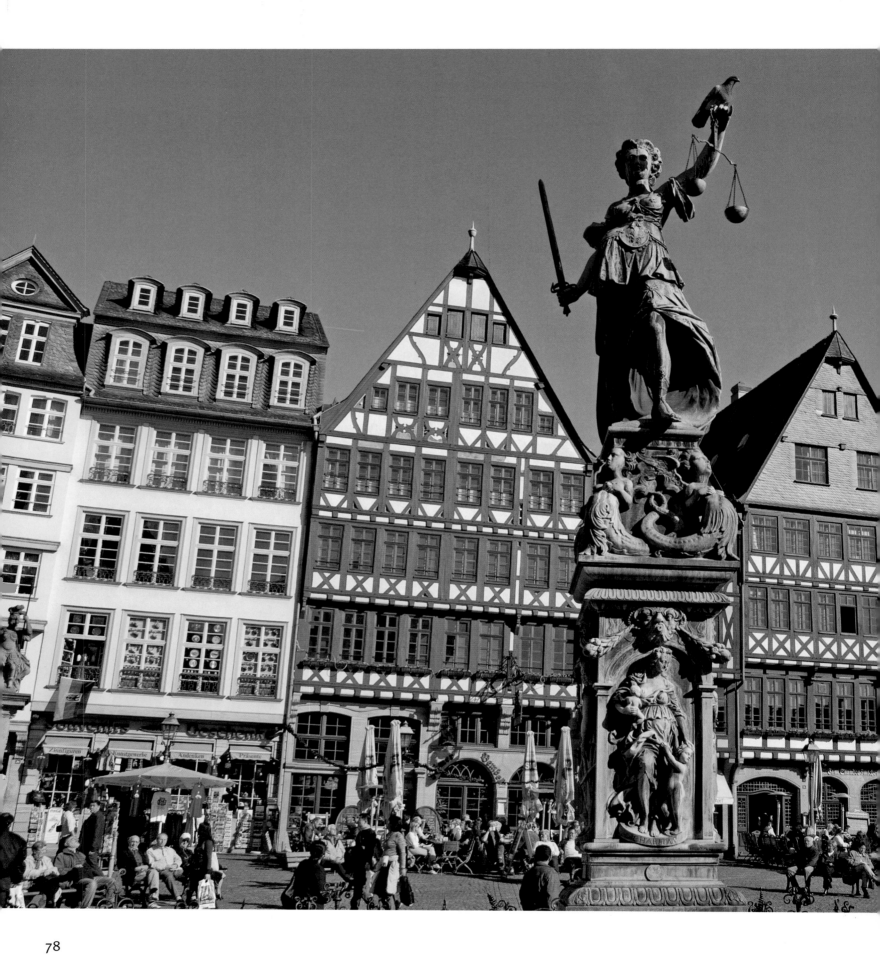

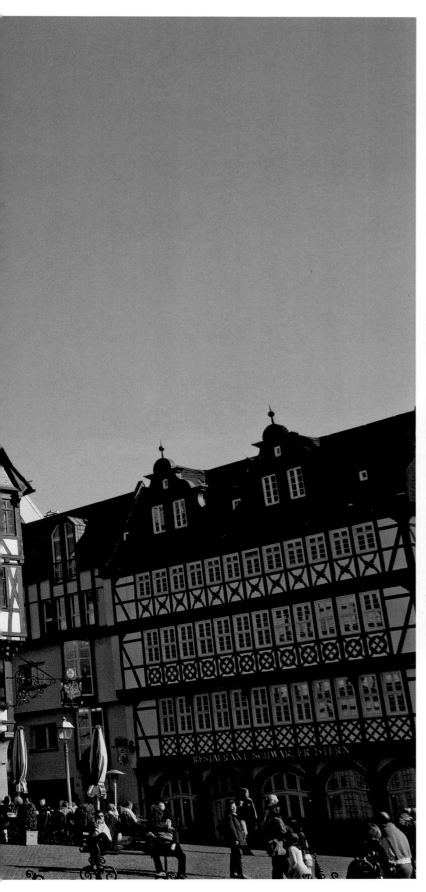

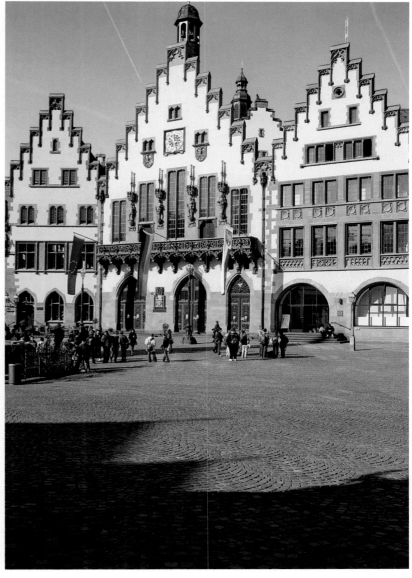

Left:
The Römerberg in Frankfurt with its picturesque façades and the fountain of Justice at its centre is a big attraction for both locals and tourists.

Above:
The Römer is an amalgamation of ancient and converted buildings. Frankfurt's famous and impressive town hall boasts an equally impressive history at the place where more German rulers were elected than anywhere else in the country.

Right:
The Goethehaus on Großer Hirschgraben, where Frankfurt's most famous personality was born on 28 August 1749 to imperial councillor Johann Kaspar Goethe and daughter of the Schultheiß family Katharina Elisabeth Textor, is a place of pilgrimage for literature buffs from all over the world.

Far right:
The imperial cathedral of St Bartholomew's has changed its appearance several times. In the 13th century the Carolingian nave was replaced by an aisled, early Gothic hall church, with a new choir begun in 1305. The tower dates back to the early 15th century.

Below:
Perhaps the most famous painting of Goethe is this one, "Goethe in the Campagna", on show at the Städel Museum. It was executed by Johann Heinrich Wilhelm Tischbein in 1787.

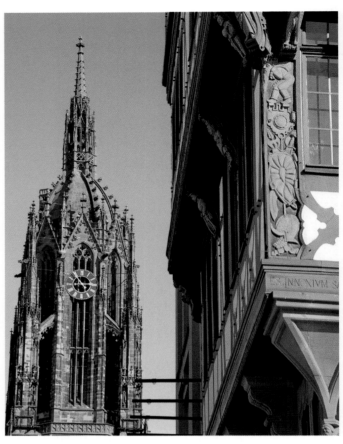

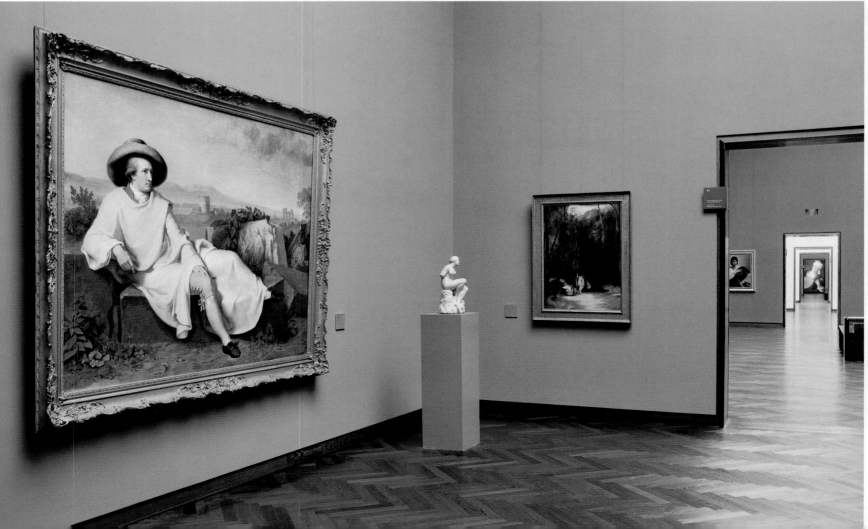

As the furnishings at Goethe's birthplace were put in store during the Second World War they escaped the bombing – unlike the building itself – and have largely been preserved, much to the joy of the great poet's fans.

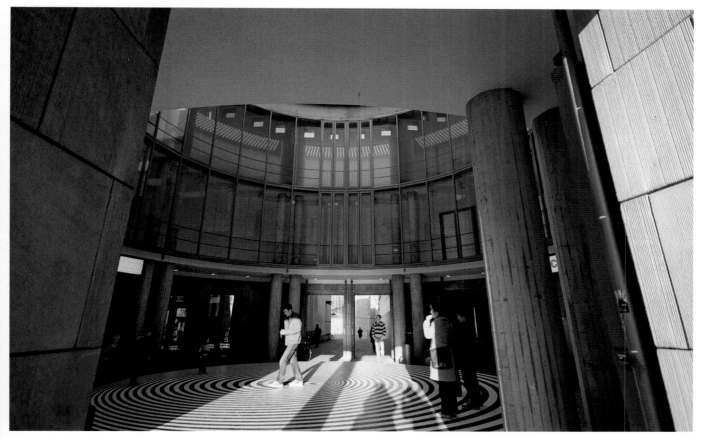

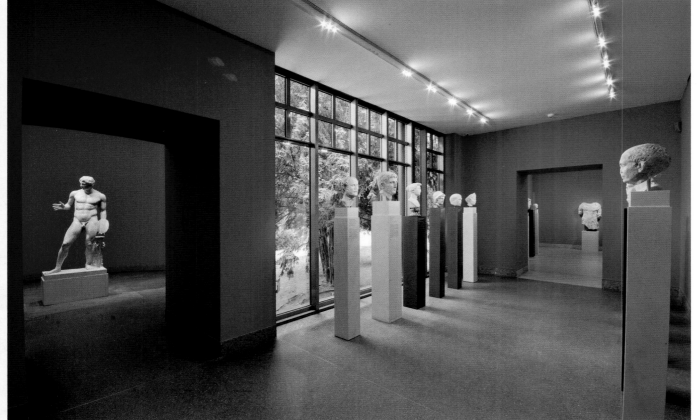

Left page:
The museum of modern art (MMK) is not just impressive on the outside (Hans Hollein, Vienna's old master of Post-Modernism, opted for a triangular plan); its interior is almost ritual in its layout, with new, surprising perspectives opening up on every turn.

Although only opened in 1986, the Schirn art gallery is one of the best known on the Continent. It has no stock of its own but makes a name for itself with its various top-notch exhibitions of loaned works with a specific theme and/or by very famous artists, including Matisse, Kandinsky, Chagall and Giacometti.

The Liebieghaus, formerly a villa owned by textiles manufacturer Baron Heinrich von Liebieg, now houses Frankfurt's collection of sculpture which features many highlights of this genre dating from Antiquity to Neoclassicism.

Above:
Frankfurt at its best: Opernplatz. Here you can enjoy a fine meal in a magical atmosphere, perhaps drawing inspiration from the historical aura that surround the opera house before attending one of its high-class performances.

Right:
Modern Frankfurt pulsates the most furiously on Hauptwache. The old police station was built in baroque between 1729 and 1731 by Johann Jakob Samhaimer. The city guardsmen have long gone; shoppers and sightseers now watch over Frankfurt at the Hauptwache café.

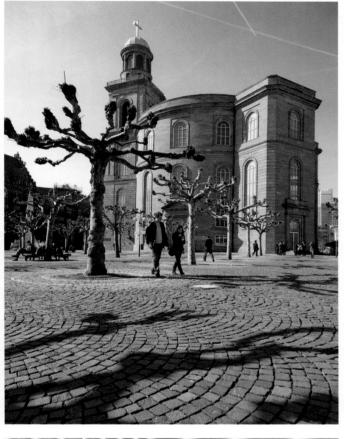

Far left:
Even if the enterprise was initially a flop, the Paulskirche from 1833 is heralded as the cradle of German democracy. This was where the first freely elected parliament in Germany held session in 1848/49.

Left:
Following its destruction in the air raids of the Second World War, the Paulskirche was the first historic building in the city to be rebuilt in simplified form – not as a church, but as a national monument.

Left page:
Bird's eye view of Frankfurt. You don't need to be able to fly to see Frankfurt laid out beneath you, however; the viewing platform atop the Maintower, 200 metres (656 feet) high and opened in the year 2000, provides an equally lofty vista.

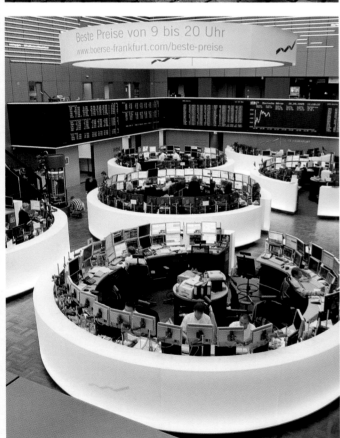

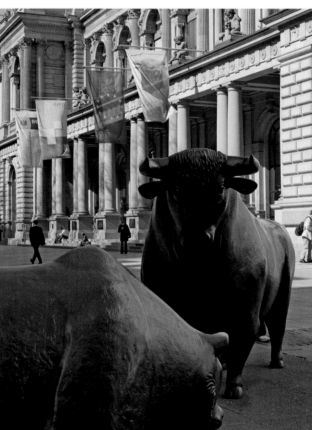

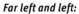

Far left and left:
The 'new' stock exchange is from the Wilhelmine period and dates back to the late 19th century. The plans for the Historicist building were drawn up by Frankfurt architects Heinrich Burnitz and Oskar Sommer. The two sculptures of the bull and the bear outside it refer to two key phrases used on the stock exchange: a bull market indicates an upward trend and a bear market a downward one. The photo on the left shows the trade hall.

89

Right page:
View from the Maintower. The distinctive twin towers of the neighbouring Deutsche Bank may be about 50 metres (164 feet) shorter but predate the Maintower by a good few years.

Right:
The Deutsche Bank skyscraper opened for business in 1984. It has three major components: a base and two towers, affectionately nicknamed Credit and Debit, each 155 metres (508 feet) high.

Far right:
Until 1997 the Messeturm, built by Helmut Jahn, was the highest building in Europe at 257 metres (843 feet). It is viewed here through one of the glass domes that roof over the entrance and exit to the Festhalle/Messe underground station.

Right:
At 208 metres (682 feet) the Westend Tower is the third-tallest high-rise not just in Frankfurt but in Germany. The gleaming crown at its apex was designed by architect William Pedersen to forge a link between our modern age and the imperial and royal coronations of Frankfurt's past.

Far right:
Castor and Pollux, the unidentical twins from Greek mythology, have been reborn in Frankfurt as skyscrapers of very different size. Castor is just 95 metres (312 feet) high, with his brother Pollux a more elevated 127 metres (417 feet).

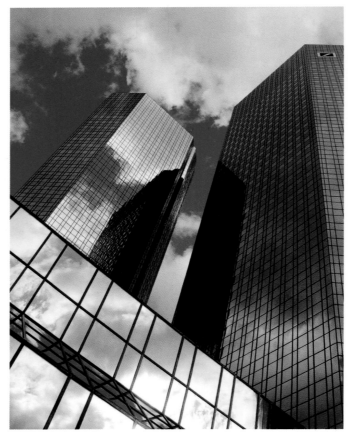

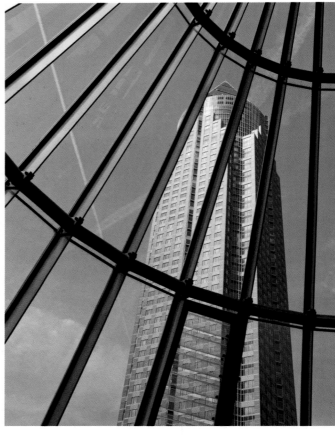

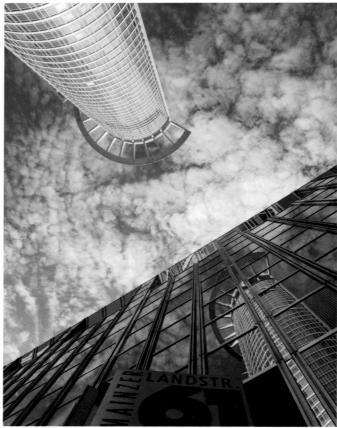

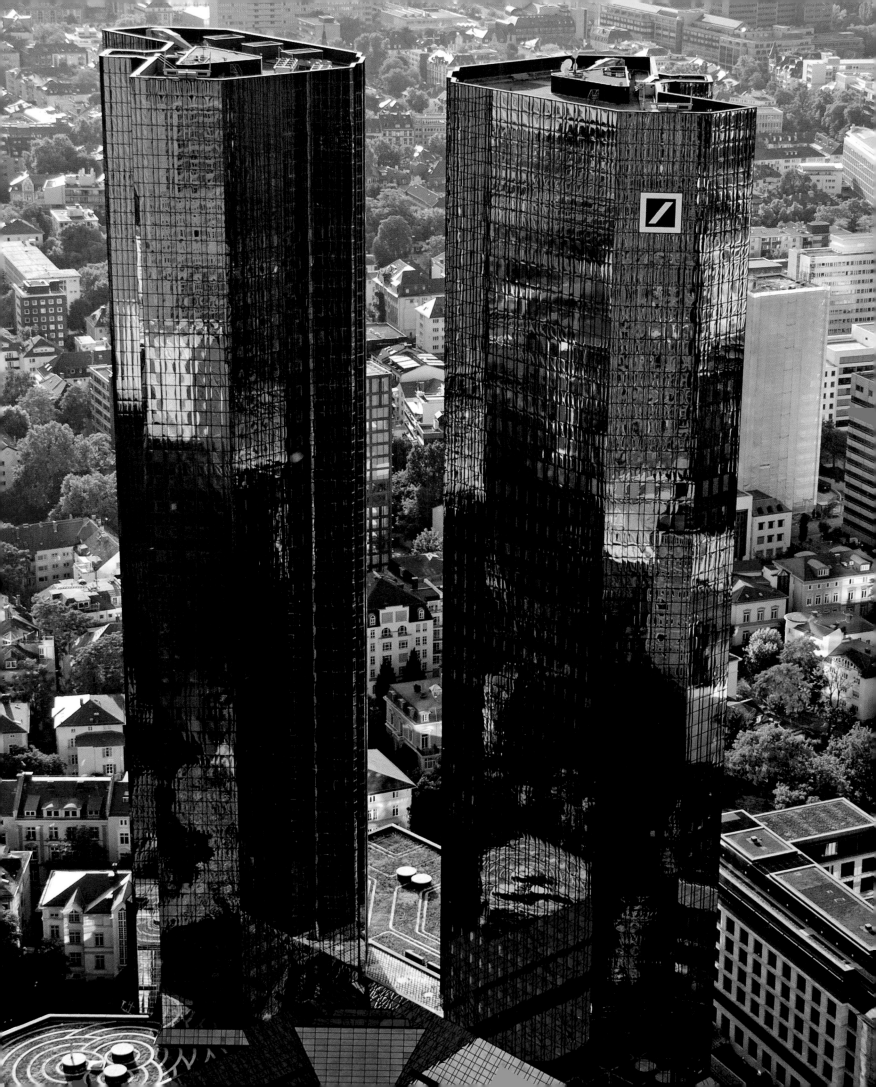

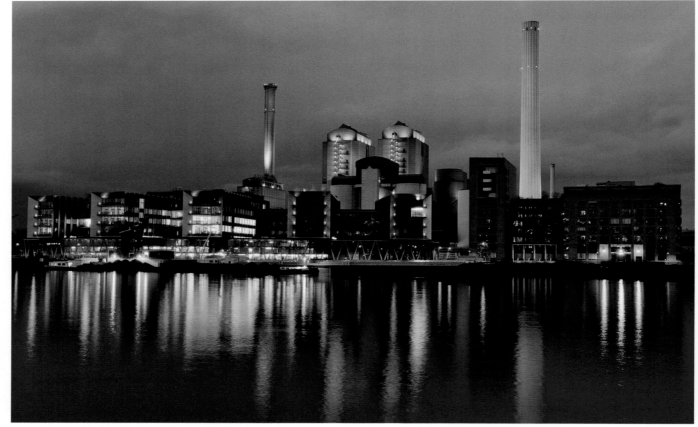

Right:
As the name would suggest, the biennial Luminale, staged as part of the Light+Building exhibition, is all about light. One of the buildings to be magically transformed is the power station at Westhafen.

Below:
The Eisener Steg footbridge over the River Main, which joins Römerberg and Sachsenhausen, has been here for almost 150 years. The view from it, however, has greatly changed during that time.

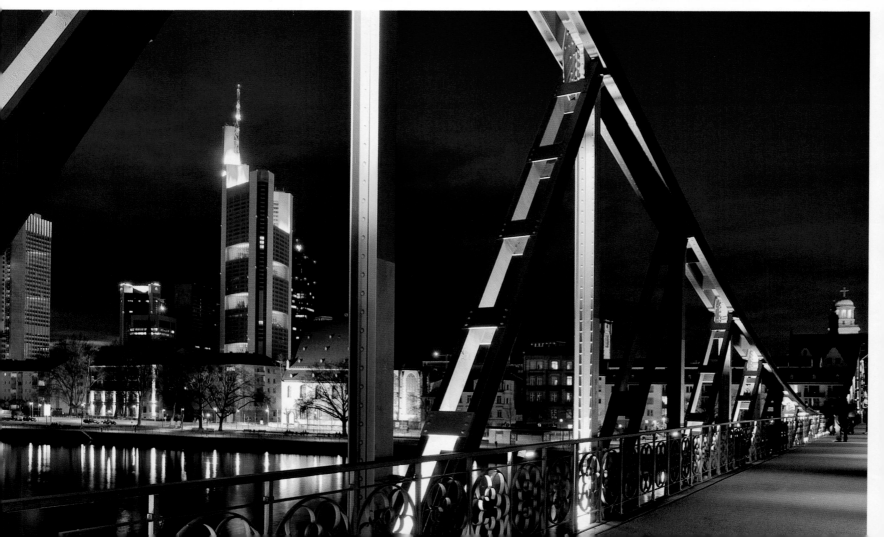

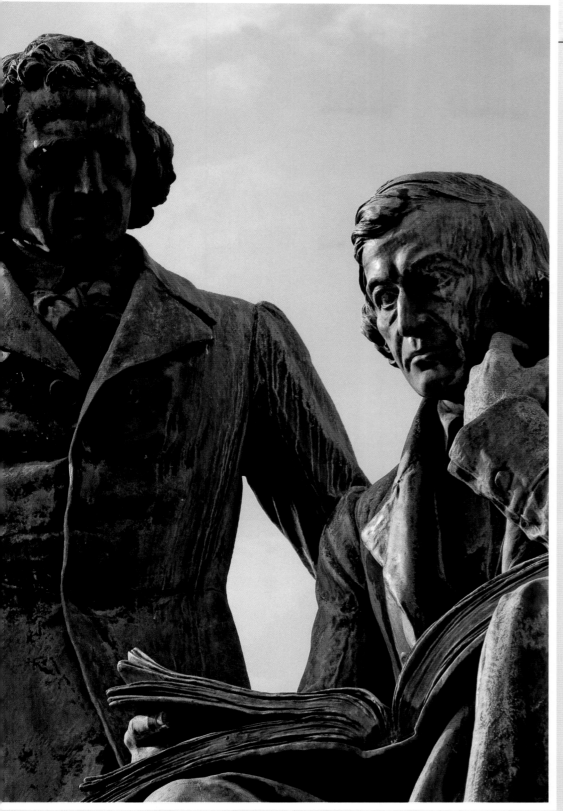

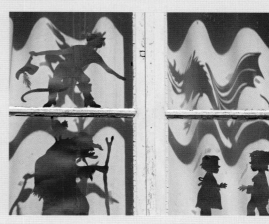

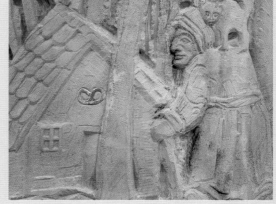

Small photos, right, from top to bottom: The house in Steinau an der Straße, where the Brothers Grimm lived from 1791 to 1798, is now a museum.

You can also come across the Brothers Grimm – vor rather, their fairytales – at the Hessenpark. Here their figures adorn a window; plays of their stories are also staged here.

The fairytale fountain erected in Steinau in 1985 depicts several of the best and most famous tales by the Brothers Grimm.

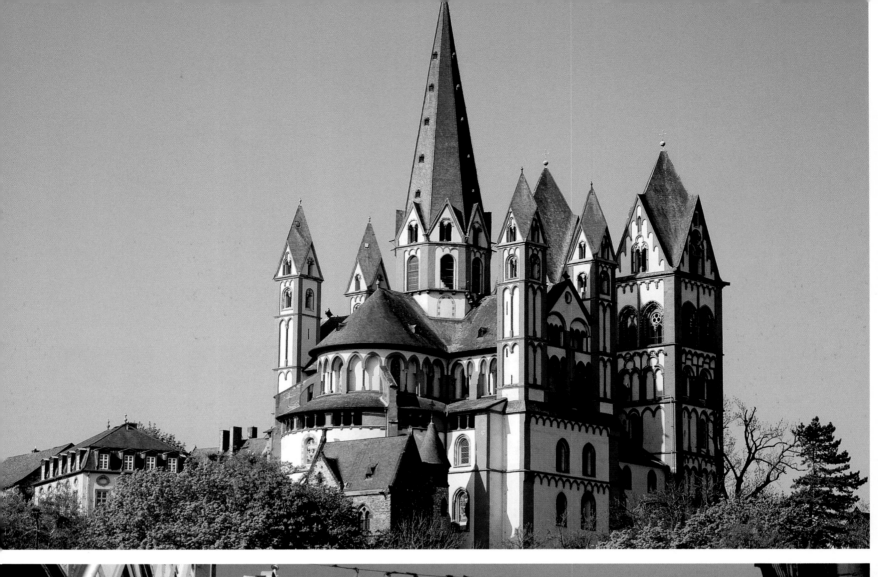

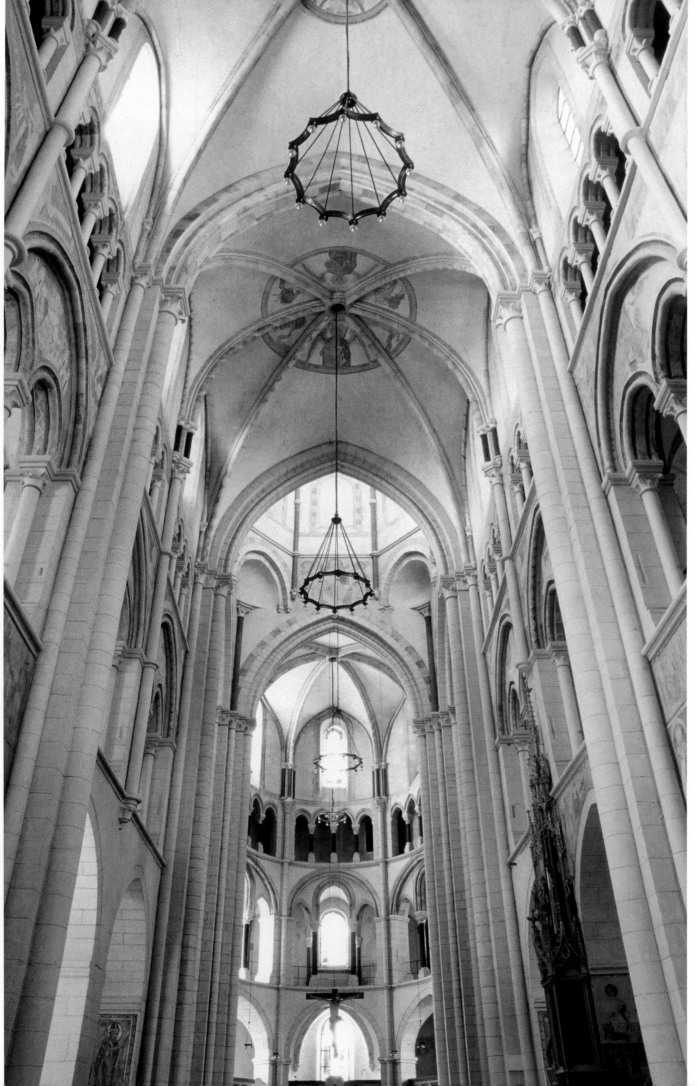

Top left page:
The cathedral of St George and St Nicholas in Limburg on the River Lahn is one of the most splendid examples of late Staufer architecture. It was begun before the end of the 12th century and consecrated in 1235, although the towers had not been finished at that point.

Bottom left page:
House number 8 on Fischmarkt in Limburg, the oldest part of the city, was built in the mid-14th century and a second storey added in 1518. The façade facing the old fish market was constructed in 1613.

Left:
During Limburg Cathedral's latest spate of renovation the original frescoes were uncovered and missing sections painted back in. They have thus been restored to their former glory, even if the colours are less brilliant than they initially must have been.

Right:
Johann Dientzenhofer also
played a leading role in
the construction of the
city palace in Fulda, the
residence of its prince-
abbots and prince-bishops.
He provided the plans with
which the old Renaissance
building was refashioned
in the style of the Main-
Franconian baroque.

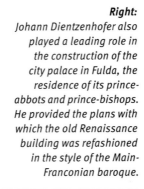

Below:
After signing his contract
with the prince-abbot in
1704 Johann Dientzenhofer
needed just eight years
to build the new cathedral
in Fulda. The furbishing
of the interior, however,
lasted until 1720.

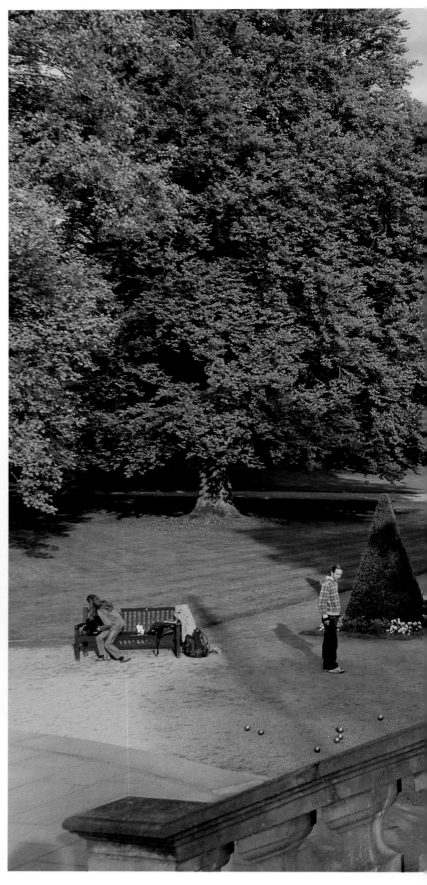

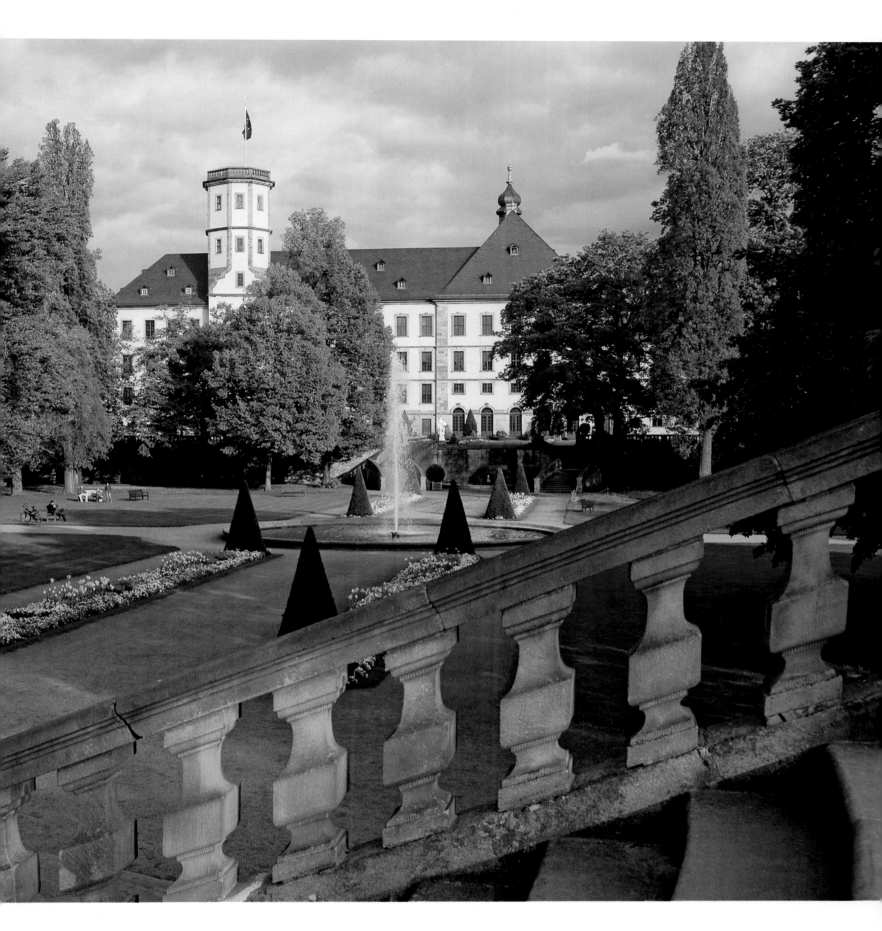

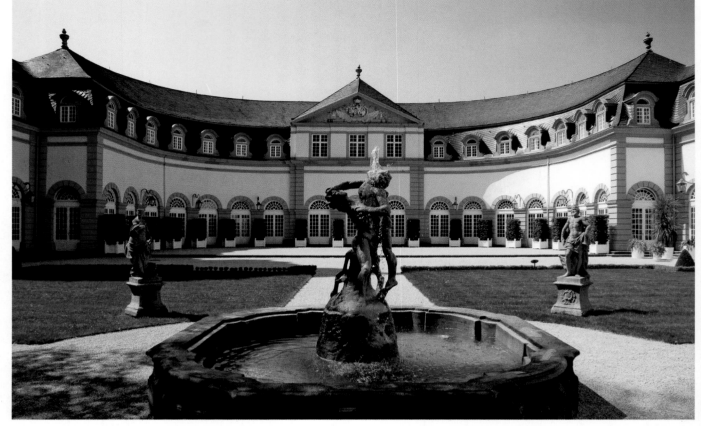

After the former Conradine stewards had become the most powerful dynasty in the southwest section of what is now Hesse, Weilburg Castle soon proved too small. In the 16th century the then counts of Nassau thus had a Renaissance palace erected and during the baroque period more buildings were added, such as the two orangeries and the church.

Schloss Eisenbach can only be viewed from outside but the beautiful park is open to the public. Non-residents can also get married in the castle church.

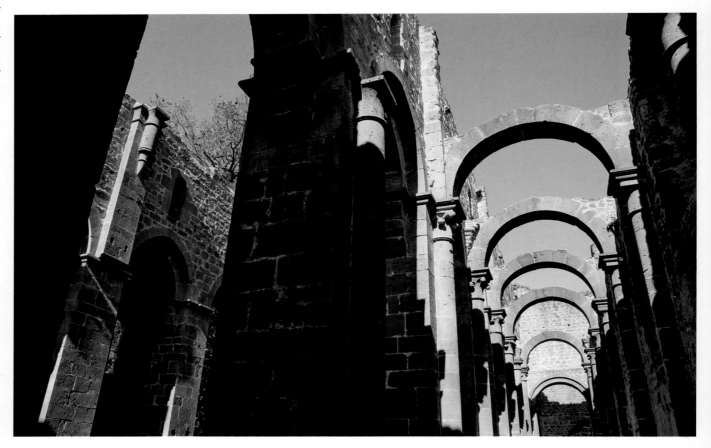

Right page:
Schloss Laubach in its present form dates back to the 16th to 18th centuries. It became a seat of residence under Count Friedrich Magnus I of Solms-Laubach in 1548, half-brother of the landgrave of Hesse Philipp the Magnanimous.

Right:
The late Romanesque/early Gothic church belonging to the Cistercian monastery of Arnsberg, founded in 1174, is now a romantic ruin. At the beginning of the 19th century the place of worship was plundered for its building materials.

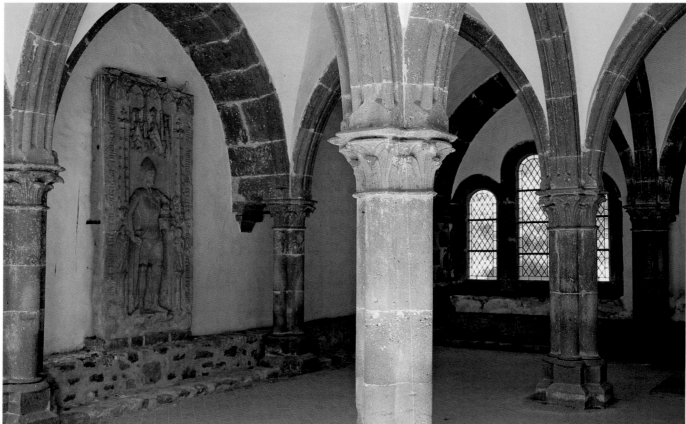

Right:
Arnsberg's chapter house is from the early Gothic period. The stone bench running round the wall suggests that the room was not fully enclosed but a continuation of the cloisters.

Page 110/111:
The old bridge over the River Lahn in Wetzlar, 104 metres (341 feet) long, 3.45 metres (11 feet) wide and with seven grand arches, has been here for about 750 years.

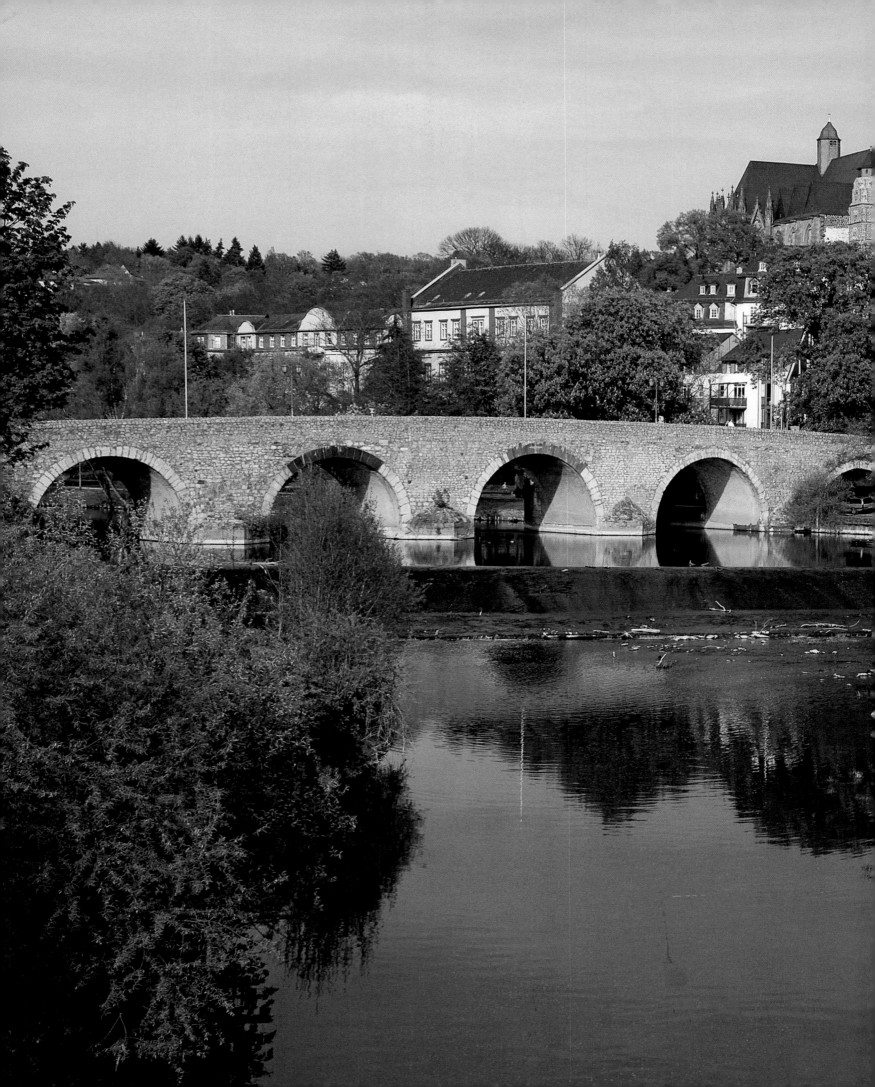

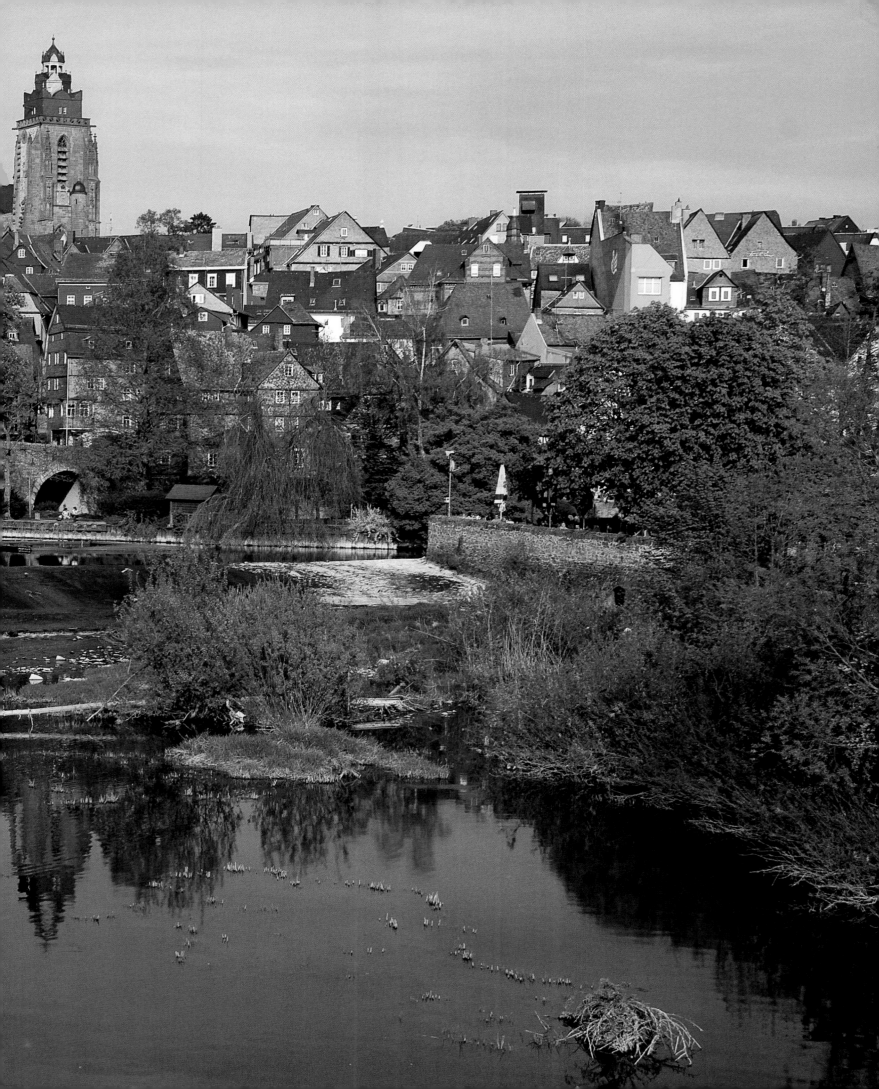

Right:
The beams of this attractive half-timbered house in Wetzlar may have warped over the centuries but this perhaps only serves to add to the charm of the ancient building.

Far right and right:
As the church and the town argued about who should finance the cathedral in Wetzlar dedicated to the Virgin Mary, it remained unfinished. Incidentally, Wetzlar never had a bishop, the name derived from the fact that one of Trier's archbishops acted as provost here.

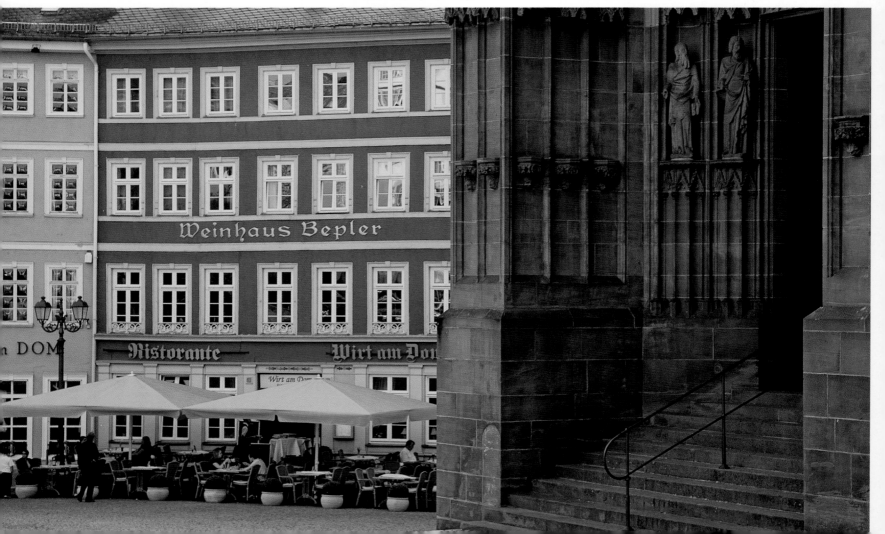

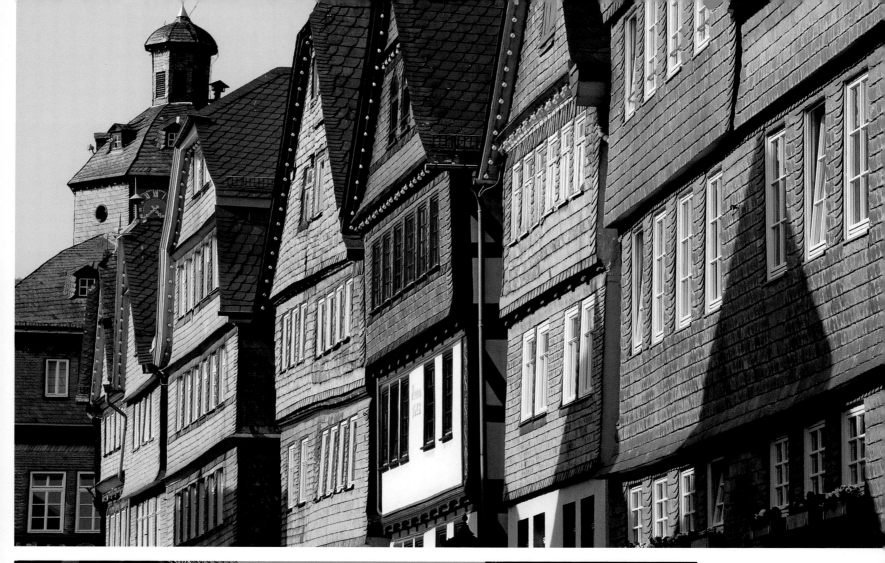

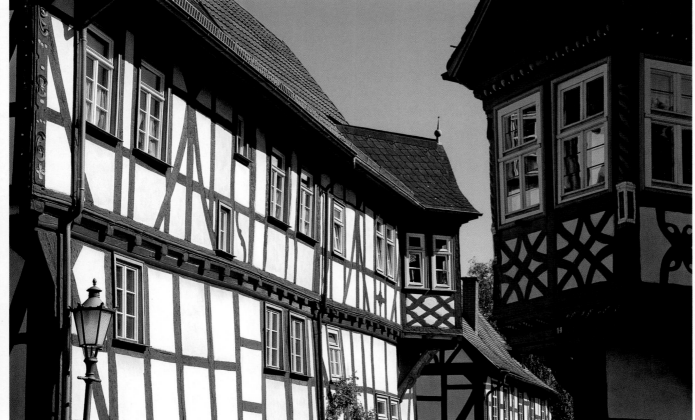

Above:
Herborn is 1,000 years old and has a veritable wealth of historic half-timbered housing. The dwellings are all very different, with some partly clad in slate, such as here on the marketplace.

Left:
The little town of Lich on the River Wetter, with a population of around 13,000, was first mentioned at the end of the 8th century and granted its town charter in 1300. It has much to admire in the way of architecture, from half-timbered town houses to the castle of the princes of Solms-Hohensolms-Lich to the vast church and the clock tower – and much more.

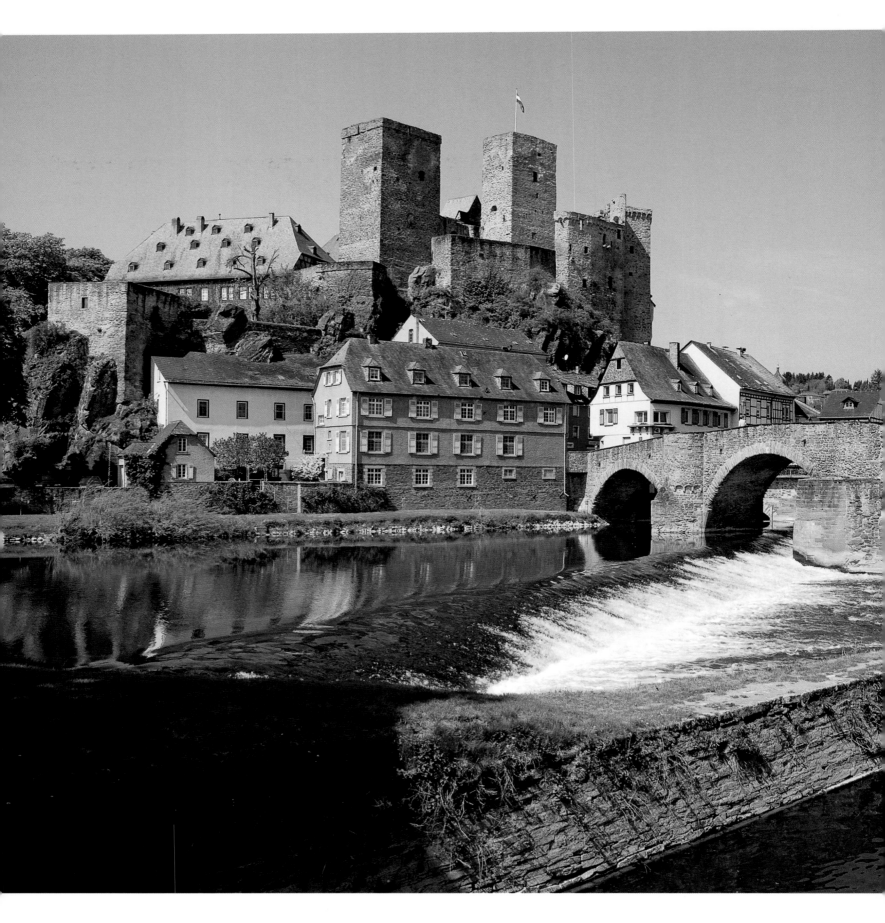

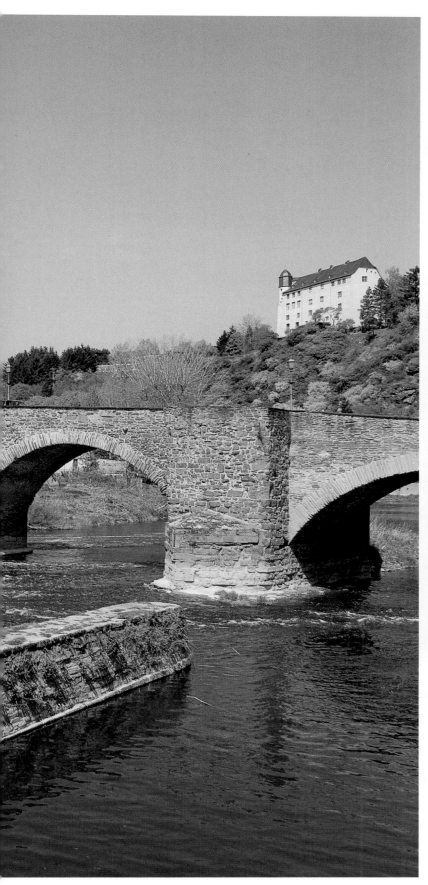

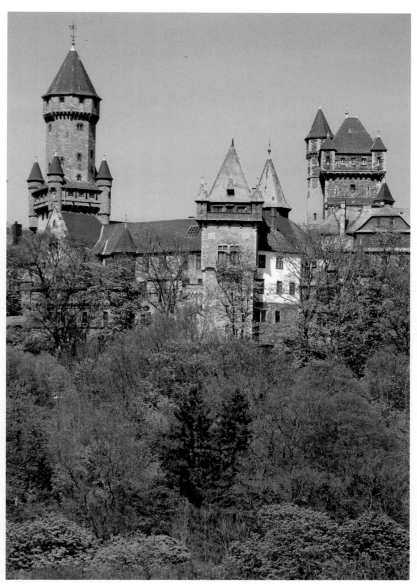

Left:
In a land so rich in castles, Runkel on the River Lahn deserves a special mention. The stronghold is not only impressive but also enjoys an extremely romantic setting, with the river and defensive stone bridge before it merely adding to its attraction.

Above:
Schloss Braunfels is Hesse's answer to Schloss Neuschwanstein. Like its Bavarian counterpart, its neo-Gothic, 19th-century embellishment is now its discerning feature. The museum here is well worth a visit for the many excellent exhibits from the Solms-Braunfels collection.

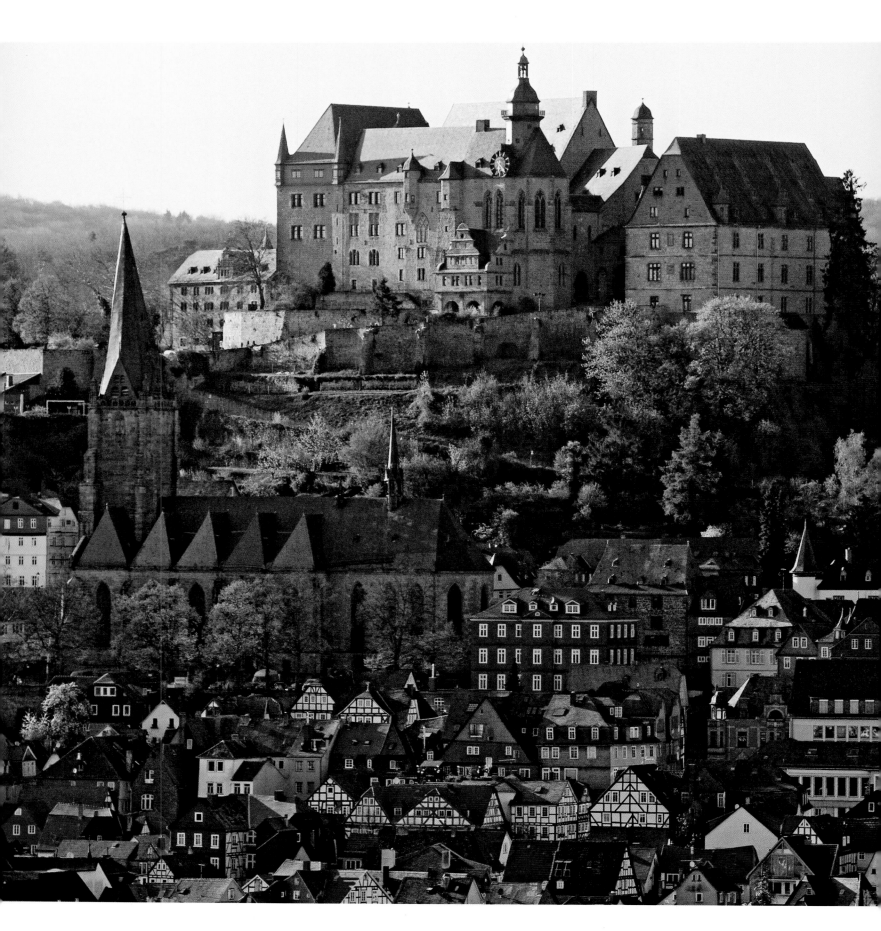

Left:
Marburg Castle, once the domain of the landgraves of Hesse, exerts a great magnetism – not just on those who visit but also on the surrounding houses that almost seem to crush one another in their attempt to be as close to its defensive walls as possible.

Below:
View across Marburg's marketplace of the historic town hall, built between 1512 and 1527. The tower with its clock gable was added a few years later. It is said that Sophie of Brabant named her four-year-old son landgrave on this very square in 1248.

Bottom:
Detail of the carved, gilt shrine of the Sippenaltar, a work by Ludwig Juppes from 1511. The shrine and altar can be found in the northern aisle of the Elisabethkirche in Marburg.

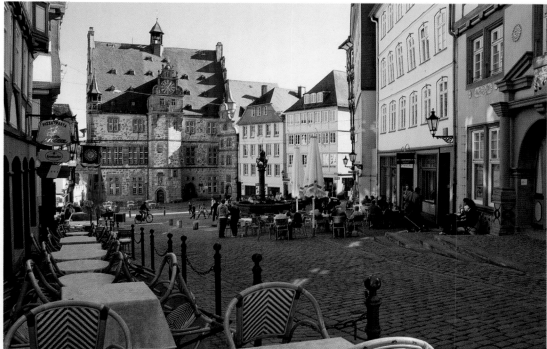

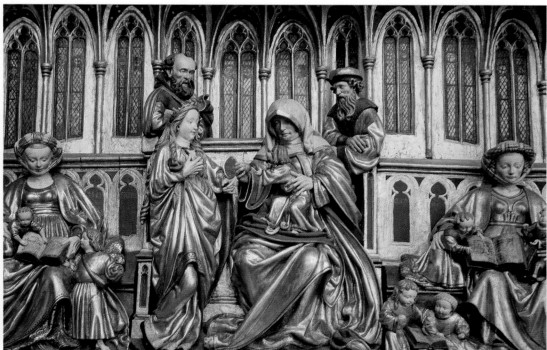

117

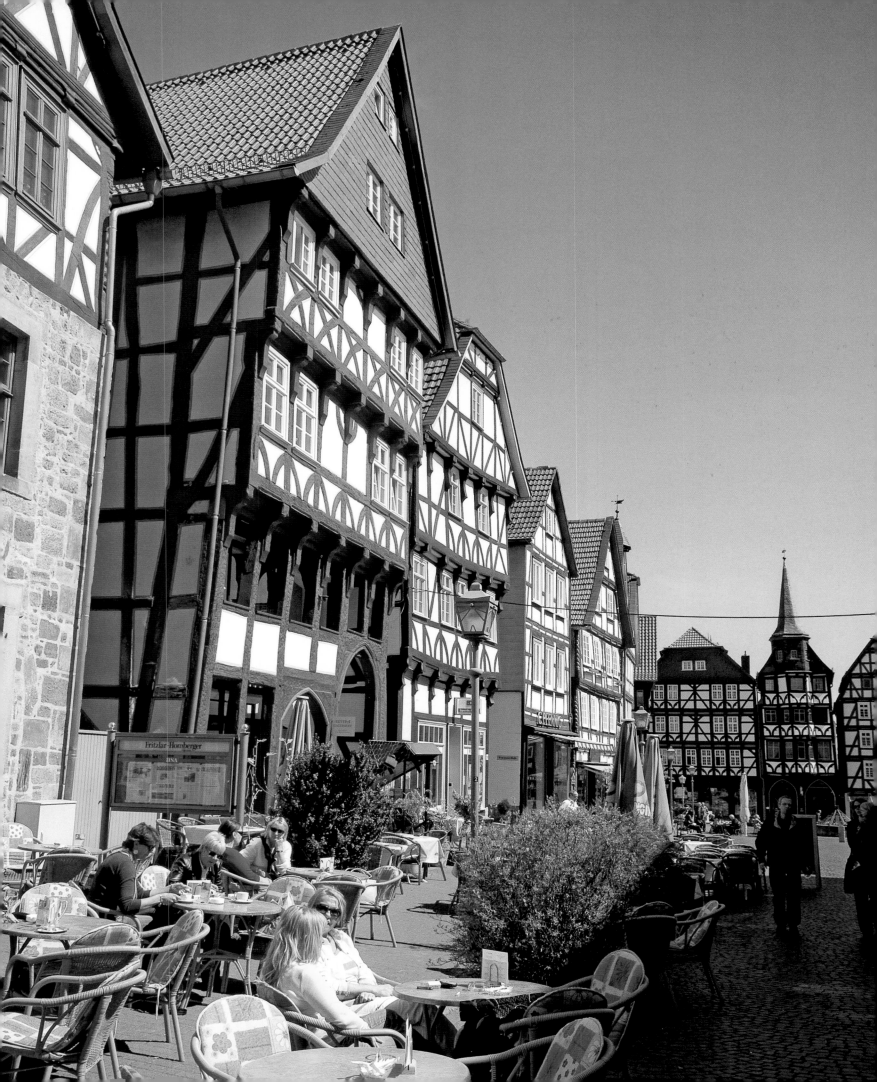

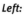

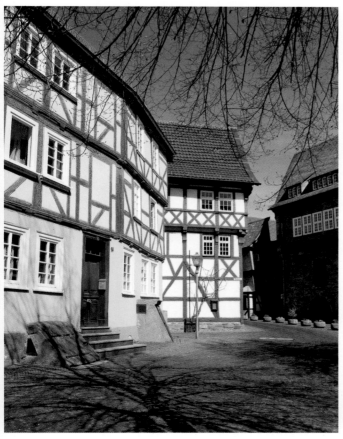
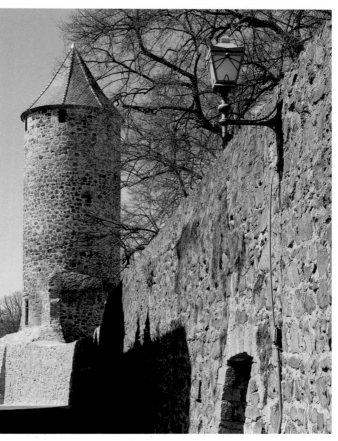

Left page:
The stuff dreams are made of: the market square in Fritzlar. If they could talk, the old houses lining the square could surely tell each other a few tales or two about days gone by.

Left:
Frankenberg, located on a ford through the River Eder and established as a military base against Mainz by the landgraves of Thuringia in the mid-13th century, also lives up to its claim to be a half-timbered town.

Far left and left:
Views of Fritzlar. The town wall was begun in the second quarter of the 13th century. It originally had thirty defensive medieval towers; only a few have survived the ravages of time.

Page 120/121:
At the start of the 18th century Julius Ludwig Rothweil built the baroque residence of Arolsen in emulation of Versailles for Count Friedrich Anton Ulrich of Waldeck and Pyrmont on the site of an old Augustinian monastery.

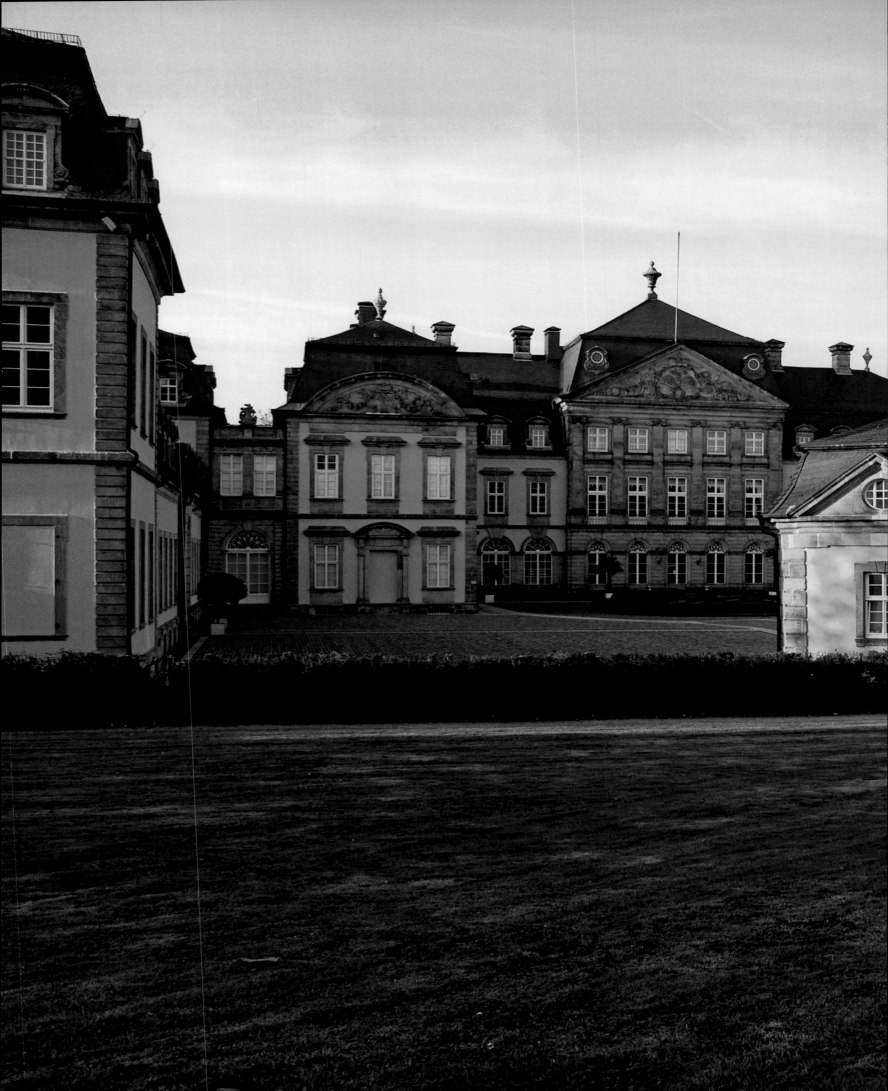

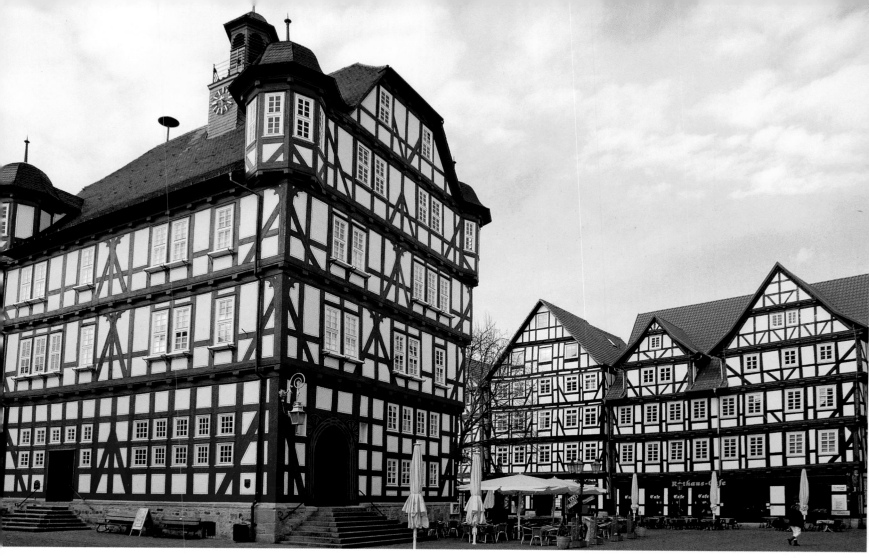

Above:
Seemingly aware of its status as the most beautiful Renaissance half-timbered building in the electorate of Hesse, the town hall in Melsungen from 1556, aloof in the middle of the marketplace, stands apart from the other timber-framed dwellings close to it.

Right and far right:
Doors can be open or closed, can invite you in or shut you out. They can also take on all kinds of decoration, such as here in Korbach (with angels) and Melsungen (framed in blue).

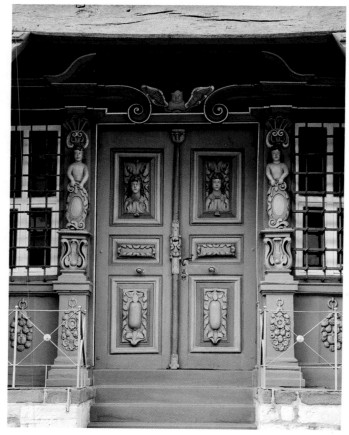

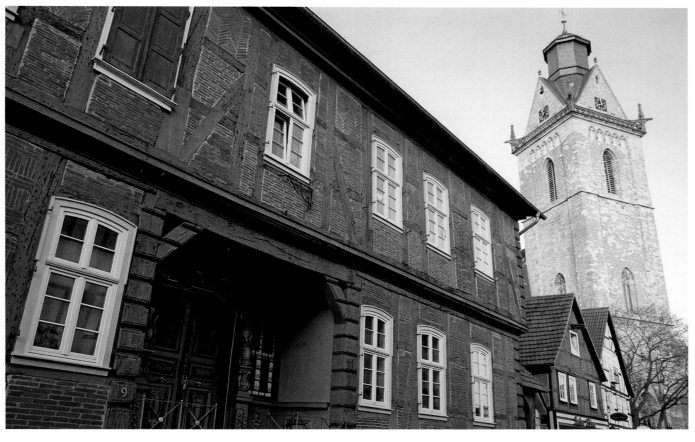

Left:
Korbach, with the steeple of St Kilian's rising up on the right in the background. In the foreground on the left is the Hartwigsches Haus, a half-timbered edifice from 1710, the entrance of which sculptor Josias Wolrad Brützel from Waldeck once embellished with the faces of angels.

Below:
Bad Karlshafen, built in a swampy area between the Weser and Diemel rivers by French religious refugees in 1699, was to mark the start of a canal joining the Weser and the Rhine – if the landgrave had had his way. All that came of the project was the harbour which we see today.

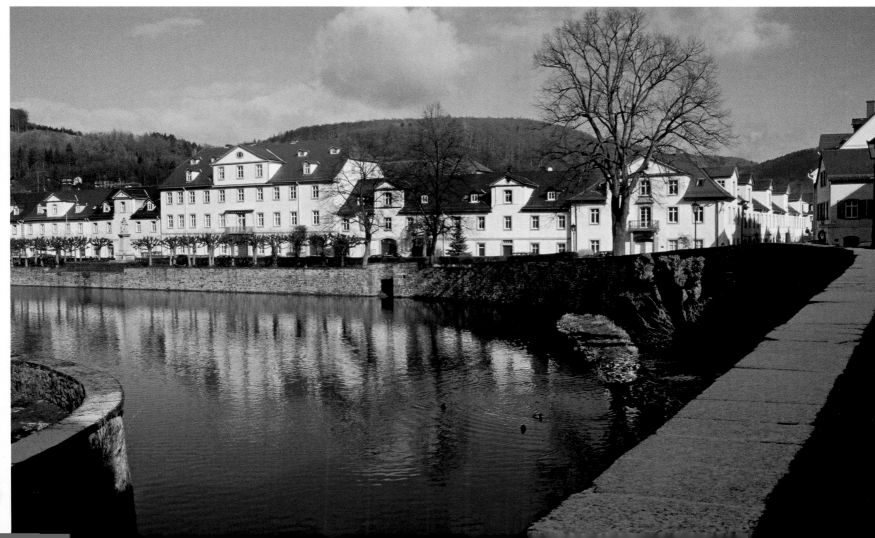

Hessentag, the oldest and biggest state festival in Germany, has been celebrated since 1961. It was initiated in the hope that celebrating regional traditions would bring locals and displaced persons closer together. Today events have a broader and more international scope.

Page 126/127:
Allendorf, merged with the spa of Sooden in 1929, can claim to have the most complex array of half-timbering in Hesse. Lit up at night, this square in the middle of town takes on a decidedly romantic air.

In Stadtallendorf about 150 groups, bands and floats took part in the celebrations to mark 50 years of the Hessentag.

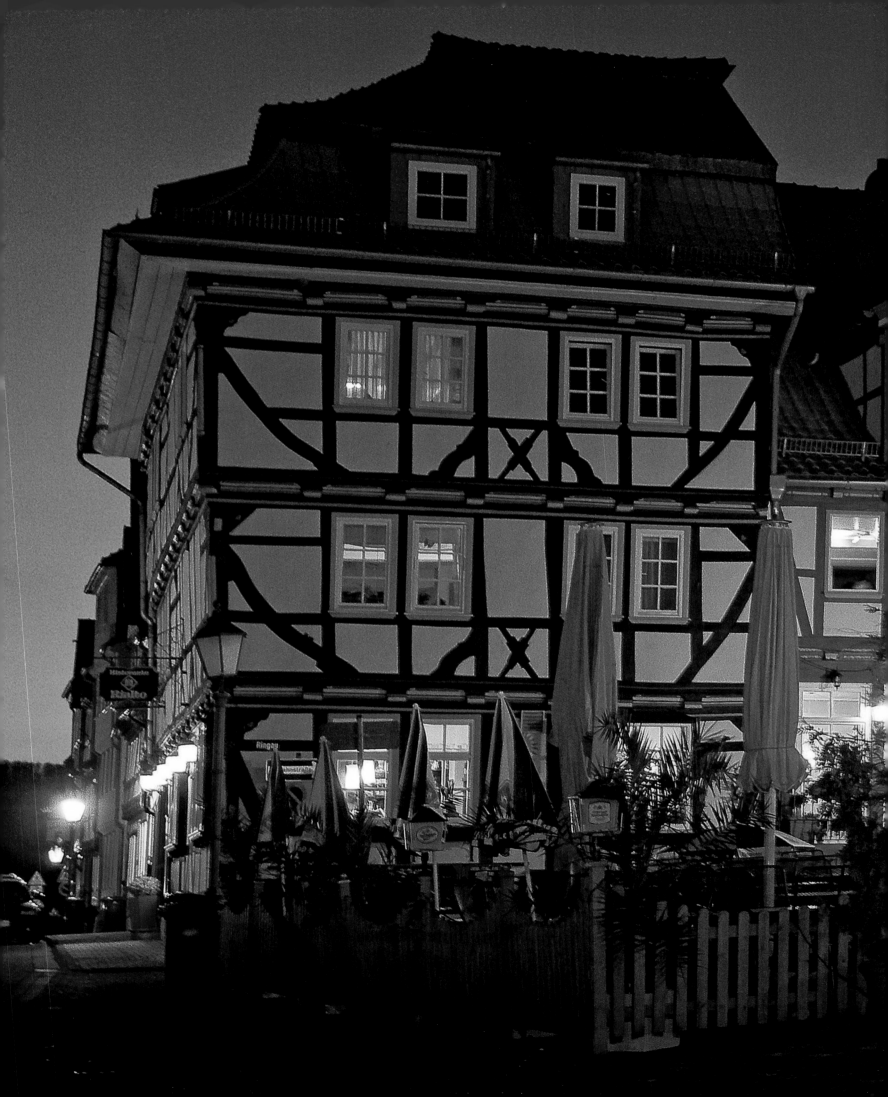

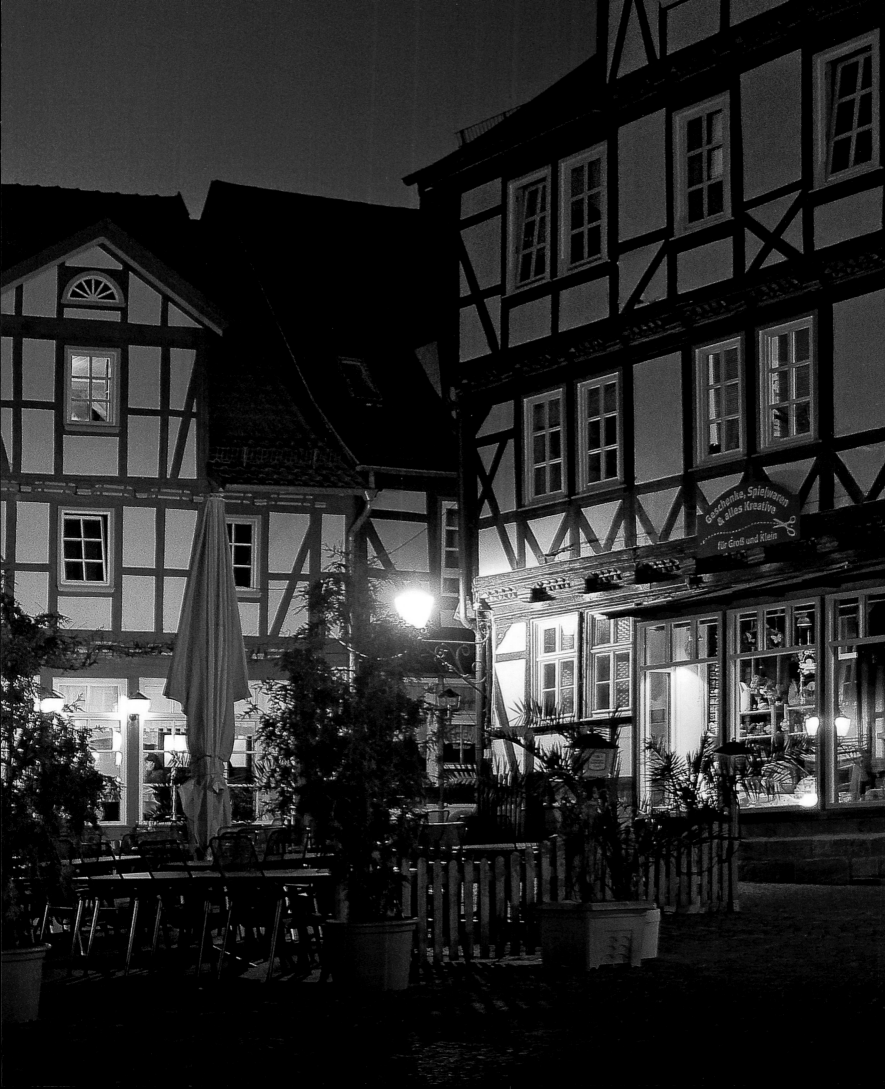

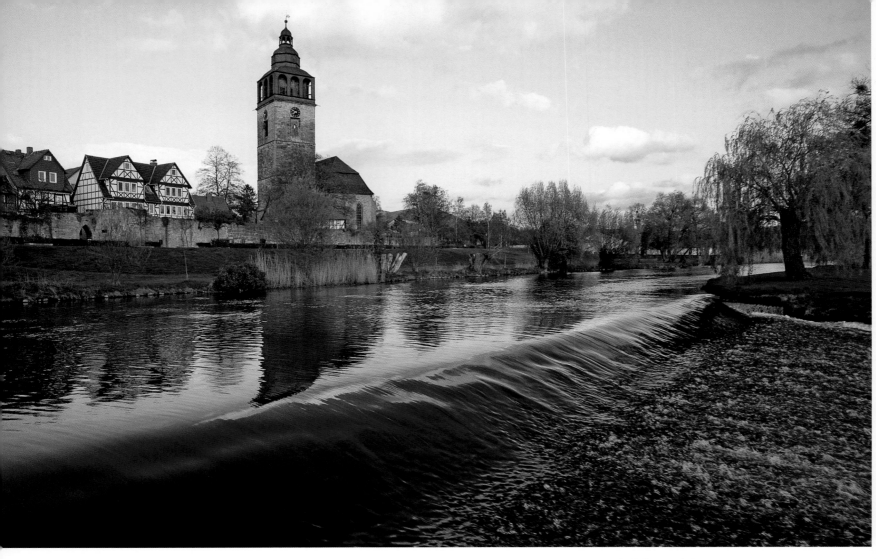

Above:
View across the River Werra of the church of St Crucis in Allendorf whose clock tower rises 62 metres (203 feet) up into the air. The origins of the church lie in the beginning of the 13th century, with parts of the Romanesque structure preserved on the south side of the nave.

Right and far right:
In 1991 the Schifflersgrund Museum was opened on the Hessian-Thuringian border between Sickenberg and Bad Sooden-Allendorf. It was the first of its kind in Germany and tells the sorry tale of over forty years of a Germany divided.

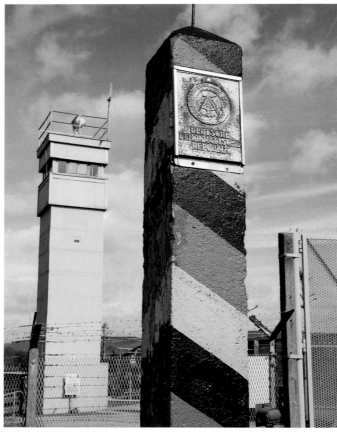

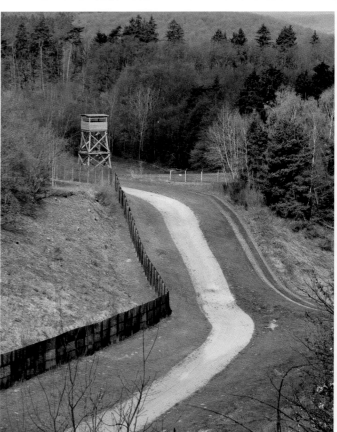

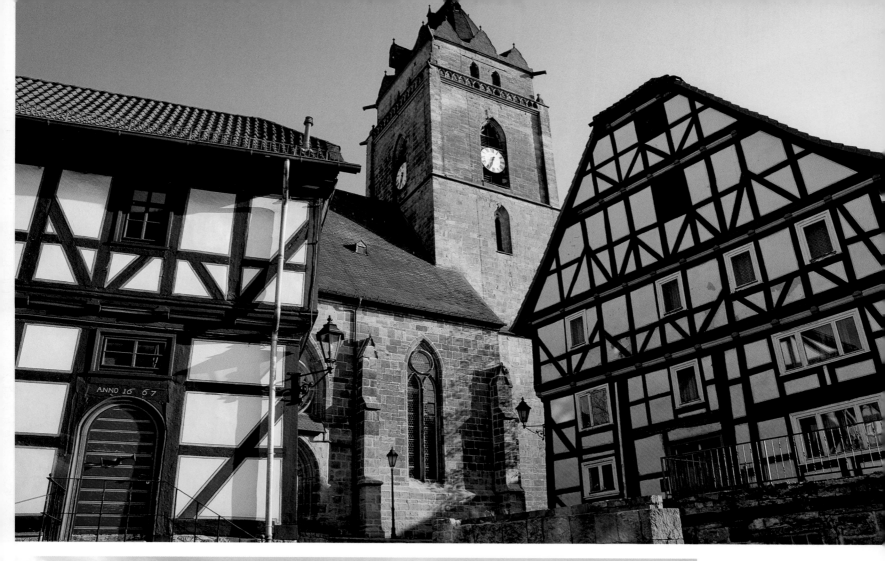

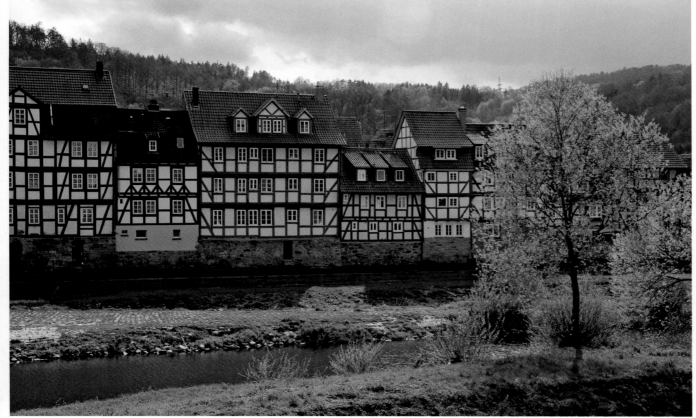

Above:
The stone church of
St Anna in Wolfhagen,
surrounded by Hessian
half-timbering. The Gothic
hall church is about
50 metres (164 feet) long,
22 metres (71 feet) wide
and 25 metres (82 feet) tall.
The solid-looking steeple
was put up in the first half
of the 14th century.

Left:
This lovely row of historic
houses can be admired
in Rotenburg on the River
Fulda. The town evolved
around the Thuringian
castle that gave it its
name. Rotenburg fell to
Hesse in 1264 and from
1267 to 1834 was the
official residence of the
landgraves of Hesse-
Rotenburg.

129

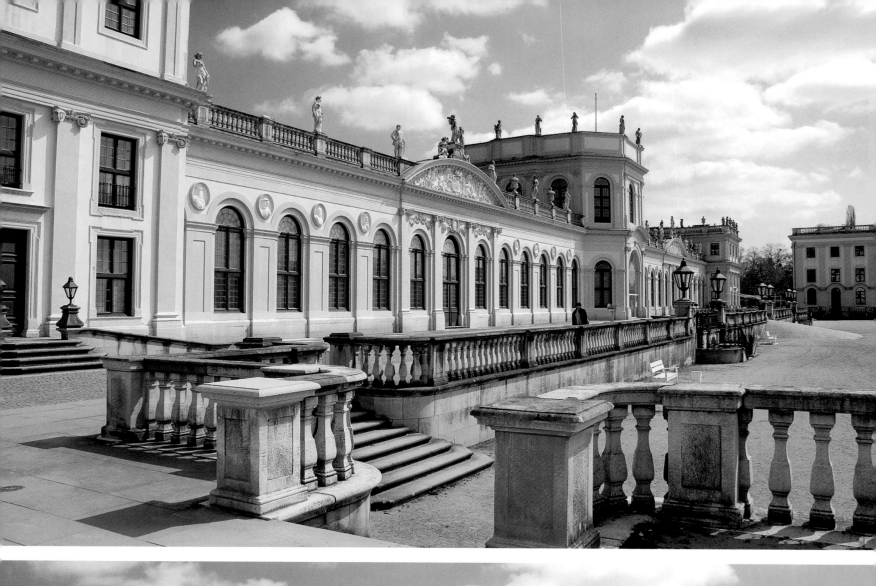

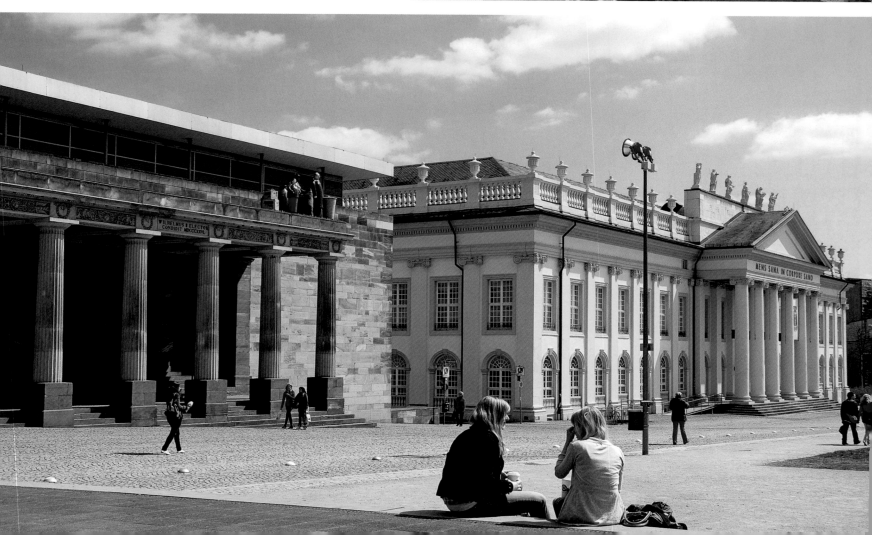

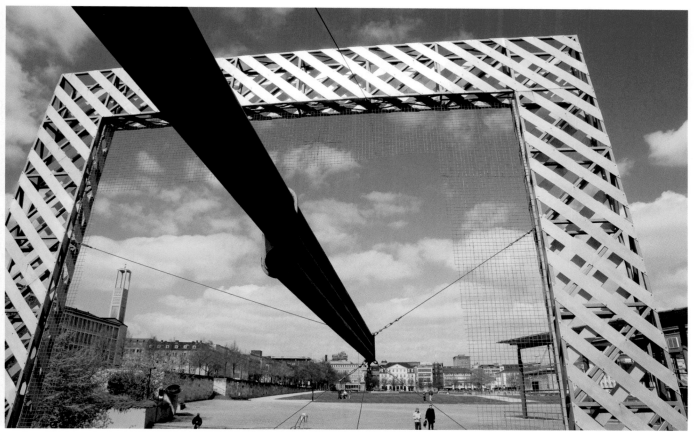

Left:
This giant frame, once the symbol of documenta 6, now stands on Friedrichsplatz in Kassel. Its creators, members of the Austrian architectural and artists' group Haus-Rucker-Co, saw it as a "[piece of] architecture for the perception and embellishment of [our] worldly surroundings".

Top left page:
The orangery in Kassel, constructed between 1703 and 1711, not only accommodated various exotic plants but also the landgrave and his guests. During the summer the corner pavilions were used as apartments, with the galleries providing ample space for any number of wild festivities.

Bottom left page:
The Fridericianum, completed in 1779, was one of the first public museums where visitors could admire the artefacts collected by the landgrave. Today the prestigious building is the setting for the documenta art exhibition every five years.

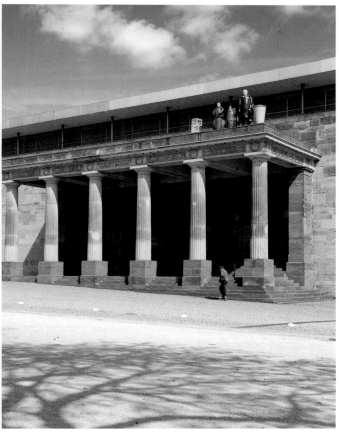

Far left:
American artist Jonathan Borofsky called this sculpture "Man Walking to the Sky", designed for documenta 9 – and you can see why. His man already seems to be half way there ...

Left:
These ceramic figures on the balcony of the destroyed Rotes Palais on Friedrichsplatz in Kassel (with Leffers department store behind it) are part of a group created by Thomas Schütte for documenta 9.

Right page:
This fantastic view of the cascades in Kassel is not reserved for the giant copper statue of Hercules alone but is available to everyone who visits the hero in his lofty palace.

Top right page:
Kassel's figure of Hercules is eight metres (26 feet) tall and about 200 years old, fashioned by a copper-smith from Augsburg. Getting on in years, he no longer threateningly swings his cudgel but allows himself to use it as a support.

Schloss Wilhelmshöhe in Kassel is one of the domineering architectural features of the hilltop park of the same name. The older Moritzschloss was replaced by the south (Weißstein) wing in 1786 and later by the northern pavilion (Kirch Wing). The middle section is from 1798.

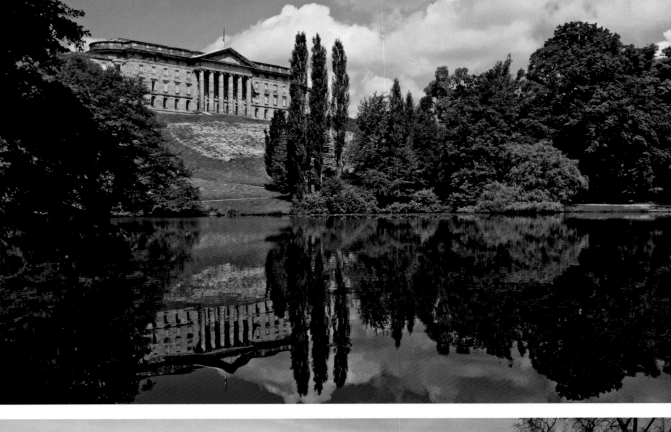

The great glasshouse in Park Wilhelmshöhe, an artistic, filigree structure of iron and glass, was created by Johann Conrad Bromeis in 1822/23, Elector Wilhelm II's court architect.

Bottom right page:
Both the Teufelsbrücke ("devil's bridge") and "pool of Hell" below it in Park Wilhelmshöhe make references to the underworld, with its lord and master Pluto lurking in a nearby cave.

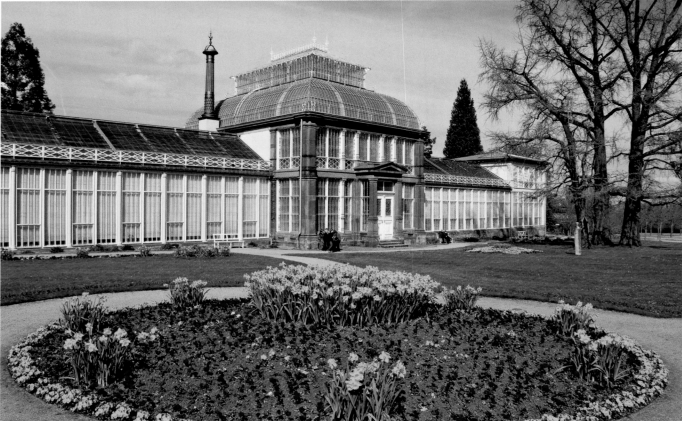